whipper snipper nerd

selections from the zine
featuring artists of Creativity Explored

edited by
Harrell Fletcher & Elizabeth Meyer

manic d press
san francisco

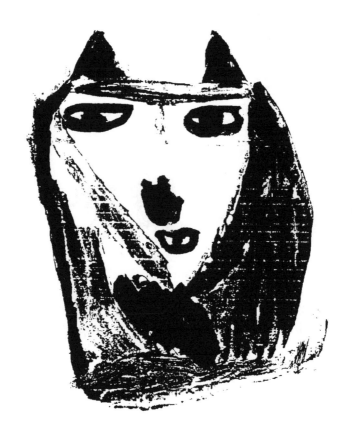

LASSIE

artwork by Barbara Doehrman / WHIPPER SNAPPER NERD #4

CONTENTS

creativity explored
WHERE ART CHANGES LIVES

Creativity Explored gives artists with developmental disabilities the means to create and share their work with the community, celebrating the power of art to change lives. Opened in 1983 in San Francisco's Mission District, Creativity Explored provides workspace, instruction, and access to a wide variety of media, including printmaking, painting, drawing, sculpture, ceramics, and fabric art. At Creativity Explored, studio artists have the opportunity to earn income from the sale of their artwork and to pursue a livelihood as a visual artist to the fullest extent possible. www.creativityexplored.org

In 1993 we began volunteering at Creativity Explored, where we got to know and become great fans of the amazing and talented artists working there. Wanting to build more awareness of their lives and art, we made videos with several of the Creativity Explored artists. These videos aired on Artists' Television Access, a local cable access TV show, and at a handful of festivals. We also started a small edition photocopied magazine, or zine, which would focus on one artist at a time, showing a selection of their work and including an interview to give a sense of the person behind the art. John Patrick McKenzie, who is featured in Issue #3, came up with a name for it: *Whipper Snapper Nerd*. The zines were distributed through Creativity Explored, Bay Area bookstores, zine conventions, and mail order.

After we produced eight issues, along with a spin-off that Michael Bernard Loggins made called *Fears of Your Life* (an expanded edition was published in book form by Manic D Press), we were asked to curate an exhibition based on *Whipper Snapper Nerd* at San Francisco's Yerba Buena Center for the Arts in 1998.

Twenty years later, we are now revisiting the project, producing two new issues of the zine with current Creativity Explored artists Christina Marie Fong and Gerald Wiggins, and looking back at the whole experience with a retrospective exhibition at Creativity Explored. This book is a chronological compilation of selections from the ten *Whipper Snapper Nerd* issues to date.

We extend our deepest thanks to the Creativity Explored artists, past and present, for sharing their work with us and the world, and to the staff of Creativity Explored and Manic D Press who have helped to make this book a reality. We hope readers will enjoy getting to know these artists as much as we have, and will be inspired to check out more of the incredible work coming out of Creativity Explored.

Harrell Fletcher & Elizabeth Meyer

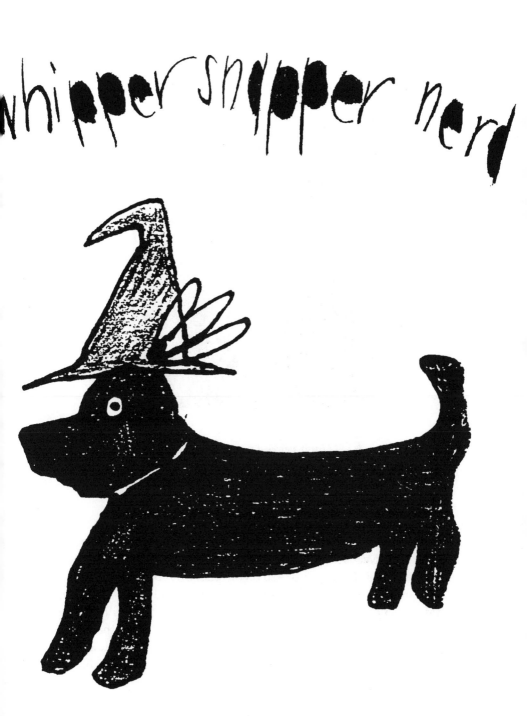

whipper snapper nerd

ISSUE NUMBER ONE

Michael Bernard Loggins
ISSUE #1, October 1994

Michael Bernard Loggins was born in 1961 and grew up in San Francisco. A prolific writer, in 1995, he began listing his fears, and 138 were published in a zine titled *Fears of Your Life*. Michael's list of fears grew, and was published in an expanded book edition by Manic D Press and read on the public radio program *This American Life* in 2003. In 2007, Manic D Press published his second book, *Imaginationally*, an illustrated dictionary of invented words. Michael's work has been shown at the Whitney Museum of American Art, New York (2004) and the UC Berkeley Art Museum and Pacific Film Archive (2011), among others. Michael worked at Creativity Explored from 1984 to 2011. He lives in San Francisco and still visits Creativity Explored frequently.

I ride the 5 Fulton Bus out by Ocean Beach by La Playa and Cabrillo to wait for the 18 Sloat Bus going towards my Brother House.

Darryl

Michael

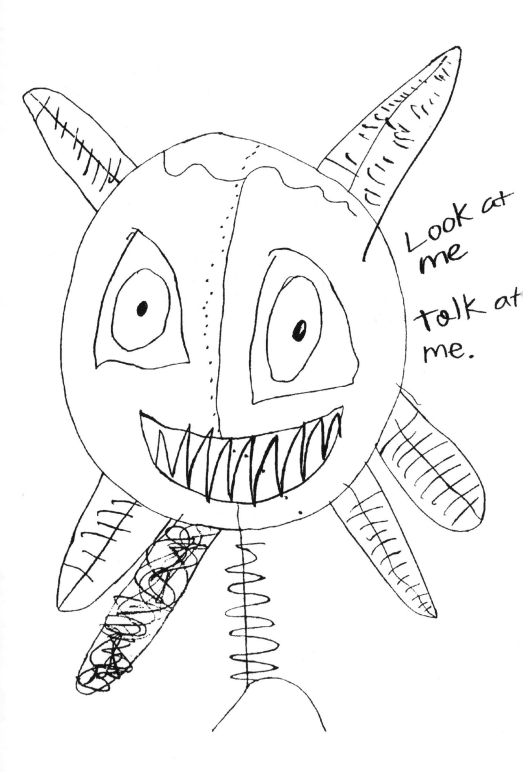

Puppets Aren't For real.
Puppets don't have no life at all.
Puppets can't talk.
Puppets don't have no house to live in.
Puppets can't swim at all.
Puppets can't Answer any Questions.
Puppets can't eat at all Period
Puppets can't Paint at all.
Puppets can't Take a bath at all.
Puppets can't go to church either.
Puppets don't have a life like we do.
Puppets can't walk across the street at all.
Puppets can't read a book.
Puppets can't drive a car at all.
Puppets can't go to work.
Puppets can't go to school either.
Puppets can't sleep in bed.
Puppets can't get up early in the morning.
Puppets can't ride on Trains.
Puppets can't cook dinner For Themselves at all.
Puppets can't learn about safety in class at all.
Puppets can't ride a bicycle at all.
Puppets can't Pay to ride on the bus at all.
Puppets can't see where they are going at all Period
Puppets don't know meanings of danger at all.
Puppets don't know the meanings of danger at all.
Puppets don't Take care of Pets.
Puppets can't cross by the light Because can't walk to the light
Puppets can't brush their Teeth at all.
Puppets can't bake a cake at all.
Puppets can't wash the dishes at all.
Puppets can't change their clothes at all.
Puppets can't sit in the chair by Themselves at all.
Puppets can't Tell The Time at all.
Puppets can't get Theirself in a lots of Trouble at all.

DOGS

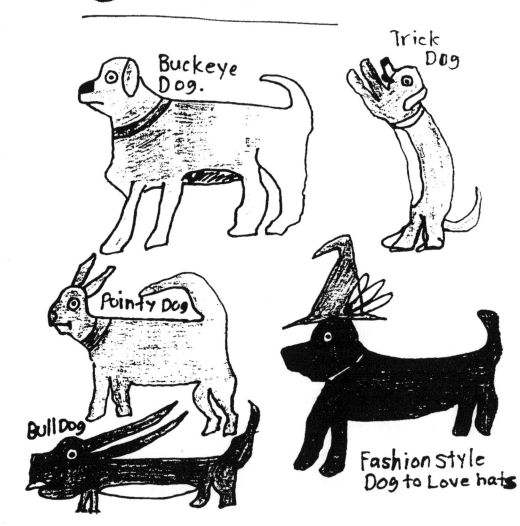

Buckeye Dog.

Trick Dog

Pointy Dog

Bull Dog

Fashion Style Dog to Love hats

I need a House to go to so I can
Protect my Family From Danger!

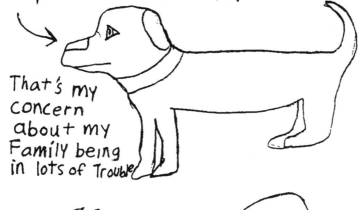

That's my
concern
about my
Family being
in lots of Trouble

I maybe a Pig dog but that don't mean
That I cannot help someone who's
ever in Trouble.

The Third Dog said I hear that somebody
need my Help and I will get over there
and Help Them.

Whoever
is or in
Trouble
really need
my help real
badly and I
better Get my
Tail over there.

13

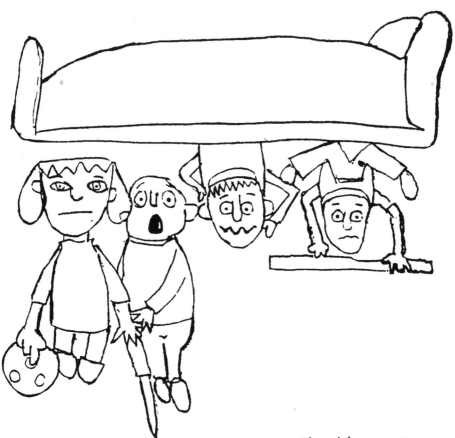

These children are called."The Four
Fearfulness children." That's what
michael call Them. And One story is
about them. But the other stories
are different. So That way you
Won't get confused With the
 Four Fearfulness children Story okay.

Four fearfulness children are afraid of the sound they might hear When they are Imaging something that are coming Toward their home. But once they hear a bump or a knock at the door, Then they get's all scare to death and then they started shaking like The wind is a leaf off The Tree. The Four fearful ness children came down From Their room to answer the door, Who is There? "The Repairman to Fix your toilet Stool!" My mother is busy. "IF you To come back tomorrow." or IF you want to come back Next week!" I'll be glad To leave your message up To her When I see her again. "Okay!" Okay said the Repairman. Be sure that you tell Your mother.

Don't Bother calling me because
I'm not going to answer it at all.

Don't come looking For me.

I had it Being holler at I can't take
it anymore.

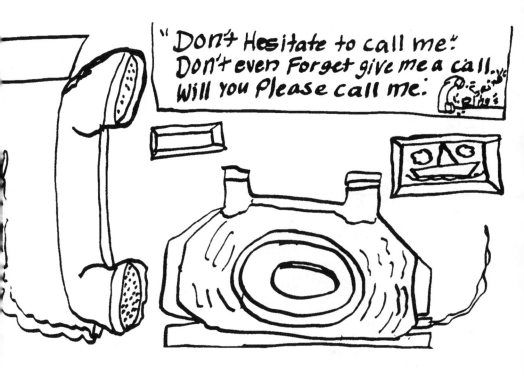

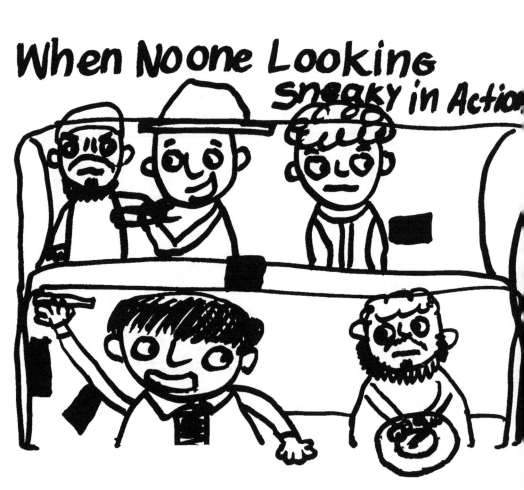

Expressing My Feelings towards my teachers! Letting them know that I am not a baby, Big baby That is:

I am a big baby.

I am Not a big baby chump.

I QUIT! I Don't want to come back ever again as long as I am living and have to be able to walk with Two Legs. I be out your way I know when I not welcome here.

I Love all of Yall

Lovely

Sunday

Anything

Wonderful

Fearfully

DaisyFlowers

Brazil

Yellow

February

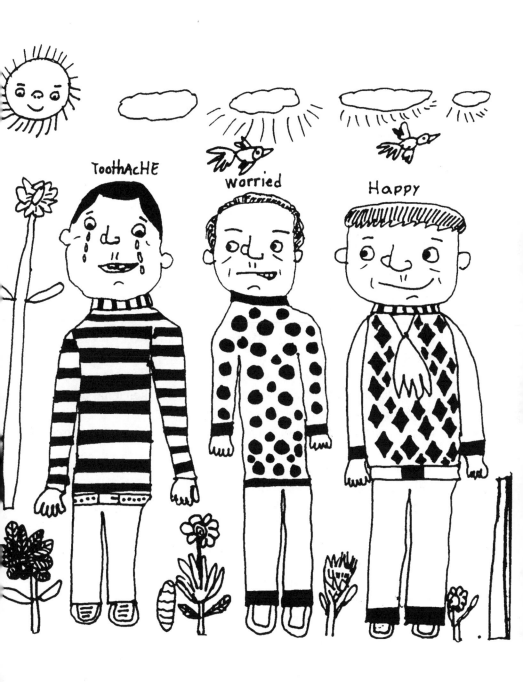

23

Michael Bernard Loggins
Interviewed by Elizabeth Meyer

Elizabeth: I guess a lot of your stories are about things that really happened to you, huh?

Michael: Yep.

E: Do you have a favorite one?

M: One is about me and Hope [Michael's girlfriend], about how we met. Another one is about going to my brother's house. Another one is about how at camp the staff tried to get me to sleep outside. They offered me a soda, but I said no way because it was too spooky for me. Too dark. There ain't no telling what might come out of the bushes and get me.

E: Did you sleep outside that night?

M: No way. I slept in a cabin.

E: What are some things that you thought would get you?

M: Anything. Lions, tigers, a person. It was so pitch black, a blur, you couldn't see anything. Would you want to do it?

E: Yeah, I would. At least for the experience.

M: You'd do it for a soda?

E: That was the bribe huh?

M: Yep.

E: In a lot of your drawings you take things that are real...

M: Reality?

E: Yeah, reality. And you mix it with fantasy. Like the drawing I have of John's Ocean Beach Cafe. That's a real place, but then it has all these things in it that aren't real. Like the giant rabbit.

M: It's just there for the fun of it. I like to add something onto it to make it more interesting.

E: Another thing I like about your work is that sometimes it's really funny. You write a lot of jokes and riddles.

M: Hope thinks I'm funny too. Funny and crazy. Crazy in a good way—you know, like hilarious.

E: One time you told me that you write jokes to make Hope laugh.

M: I'll tell everybody jokes.

E: Because you like to hear people laugh?

M: I sure do. Hope has a cute laugh.

E: Is it easy or hard to make Hope laugh?

M: I used to think it was hard, but now I found the right way, it's easy. Like yesterday, I made a joke like Tuesday bumps Monday off, and then Wednesday bumps off Tuesday, and then Thursday comes along and knocks Wednesday right out of the way.

E: I never thought of it like that before. Let's talk about what you do at Creativity Explored some more. What's a typical day like there?

M: Drawing and writing and studying. Talking to people too—volunteers and teachers and people who just walk in too.

E: Yeah, it seems like every day at least one person drops in off the street to check the place out. I've noticed that you like to show people around.

M: Yes, I do. I show them around and talk about my artwork, tell them things about it like how much time it takes me to do something. People are always asking that.

E: Does your work take a lot of time?

M: It sure does. Months and weeks... which comes first?

E: Weeks come before months.

M: Weeks and months and days. I think days come first, then weeks and months and then years.

E: That's how long it takes?

M: It depends, mostly on how many details it's got.

whipper snipper nerd

ISSUE NUMBER TWO

James Miles
ISSUE #2, October 1994

James Miles was born in 1957 in San Francisco and joined Creativity Explored in 1989. His work has been shown at many prominent institutions and galleries including the Whitney Museum of American Art (2004); the UC Berkeley Art Museum and Pacific Film Archive (2011); and the Musée de la Création Franche, Bègles, France (2013). James's work has been featured on three pillow designs for CB2 as well as one of Google's 2015 self-driving car prototypes.

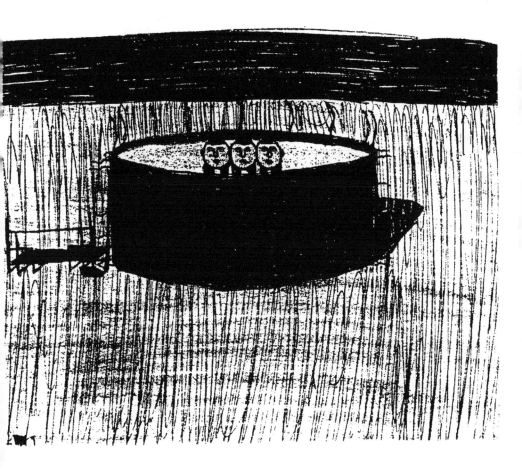

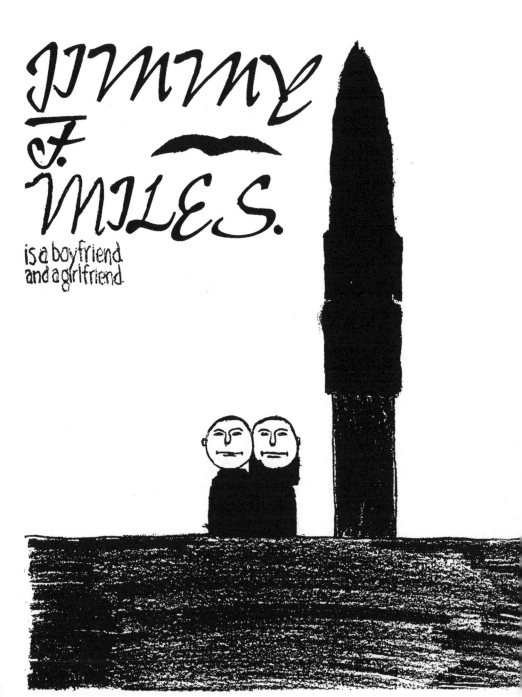

jimmy

f. miles.

eats

and

kisses

girl's

friend's

31

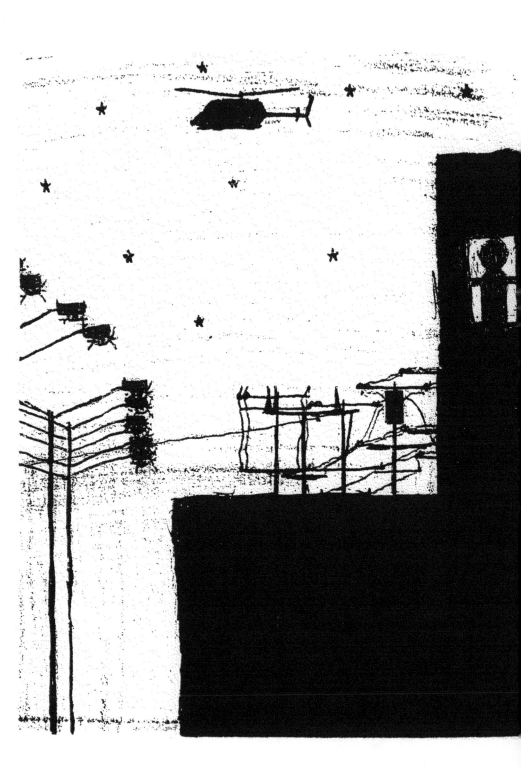

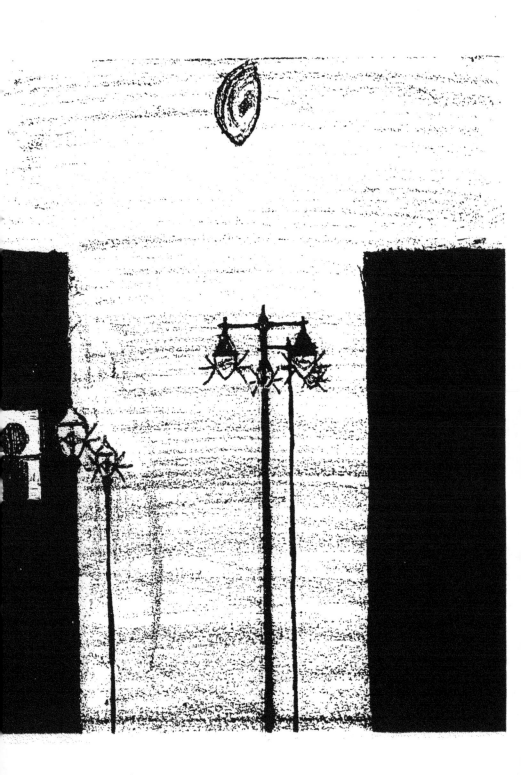

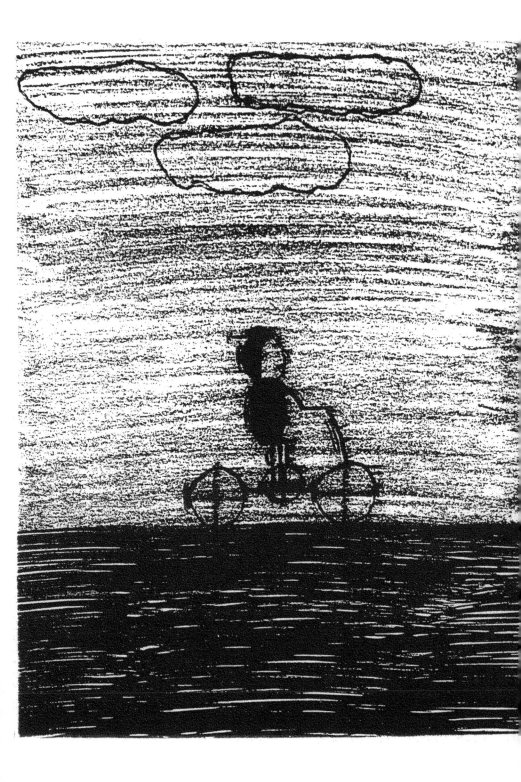

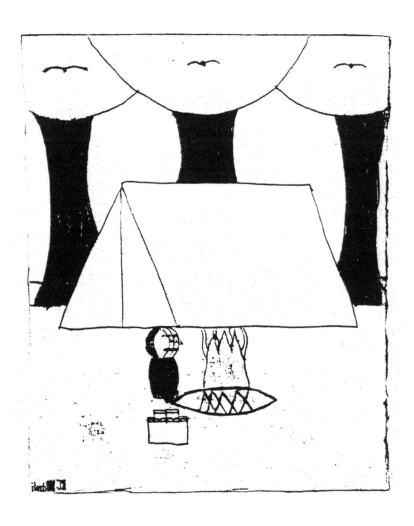

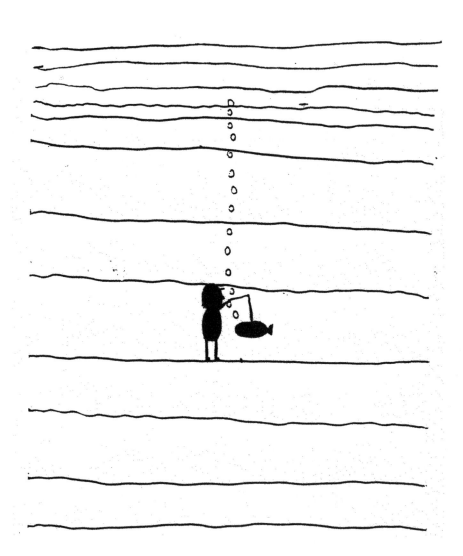

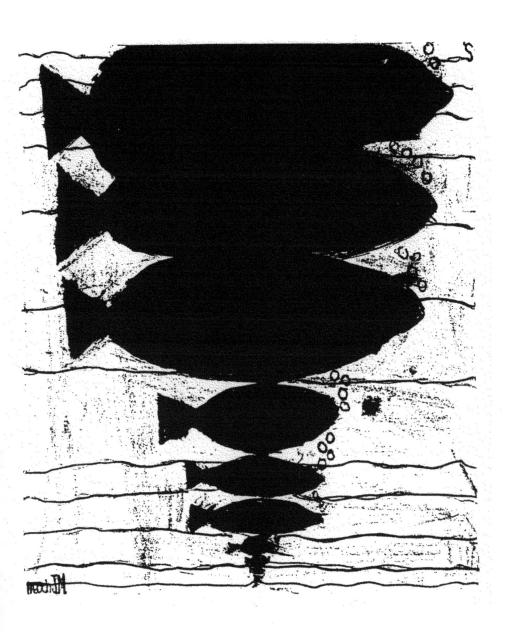

41

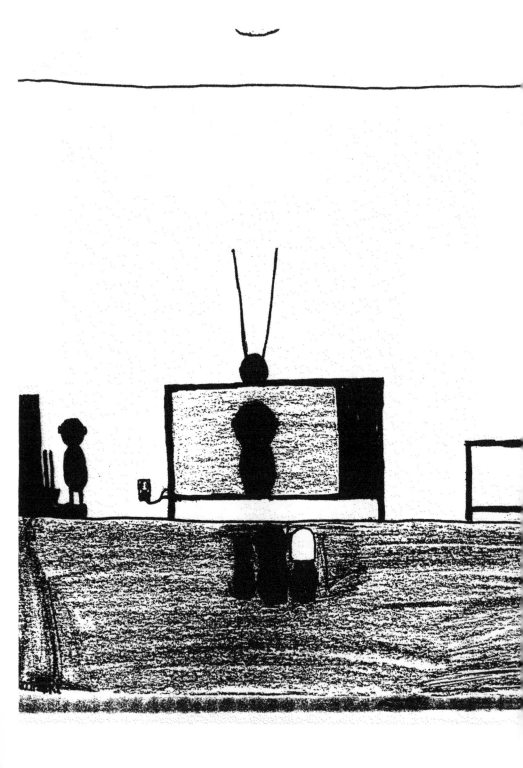

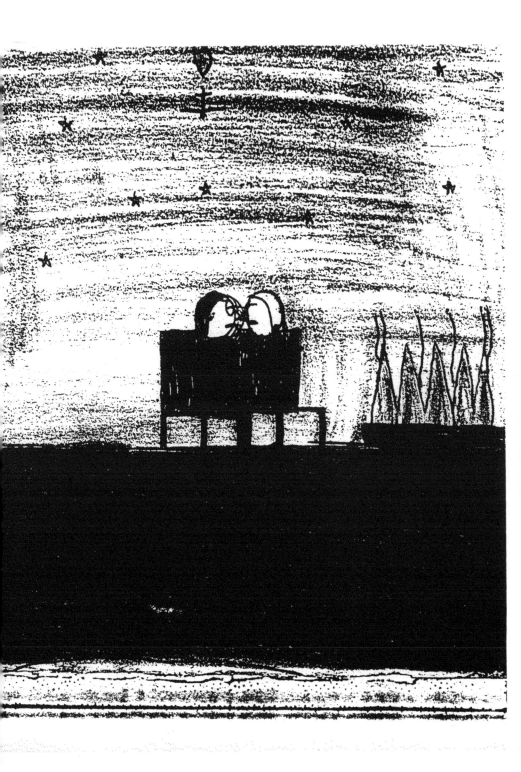

James Miles

Interviewed by Harrell Fletcher and Elizabeth Meyer

Harrell: So, tell me about your life.

James: What do you mean? I'm a drawer. Life—that means we're living beings. That's life.

H: All right. Well, if you could tell someone anything about yourself, what would it be?

J: That I'm nice. I'm pretty....

H: So, what made you decide to draw this snowman?

J: I like to. I'm thrilled. I'm excited.

H: About what?

J: I'm so glad to see you.

H: Thanks. So, what else... do you have any other drawings you want to talk about?

J: We're deadly serious.

H: Deadly serious?

J: Yes. It's very serious. It's no joke. This is a snowman.

Elizabeth: Is there anything you want to tell me about your artwork? Maybe you could tell me about the drawing you're working on today.

J: Oh, planes.

E: What do you like about planes? I see them in a lot of your work.

J: I like planes... and mountains.

E: Have you ever ridden in an airplane?

J: Yeah. I've ridden.

E: Where did you go?

J: To Hawaii.

E: Who'd you go with?

J: Mom and Dad.

E: And the people—are they people you know, like these three right here?

J: That's Diane and me and Charlene. They're nice people.

E: What are they doing?

J: Oh, watching TV. Watching *Star Trek*. ...What's the eyes for? You get it? You got it? Good.

E: OK. Got it. Do you not like it when people look at you?

J: No. It looks really weird. We don't allow it. We don't want anyone to pick on us.

E: All right. So, where do you live now?

J: On Ocean.

E: Who do you live with?

J: My family.

E: Who's in your family?

J: Oh, board and care home.

H: So, how do you like being interviewed?

J: It's great.

H: Where'd you learn to draw planes like that?

J: In my mind.

H: You see airplanes in your mind?

J: I sure do.

H: What else is in your mind?

J: A jet. A helicopter. The moon.

H: What was your first drawing of?

J: It was great.

H: It was great? What was it of?

J: Of me.

H: What did you look like?

J: Like the sun.

H: Hey, there's a question mark in your drawing.

J: Does a question mark report itself when you ask it a question? Does it get complaints when you ask questions and you want to know the answer?

H: What do you think? Does it get complaints?

J: If it doesn't know the answers.

H: So, a question mark shouldn't be asking so many questions?

J: Not if it doesn't know the answers.

H: Because then it will get a complaint? Who complains?

J: We don't.

whipper snipper nerd

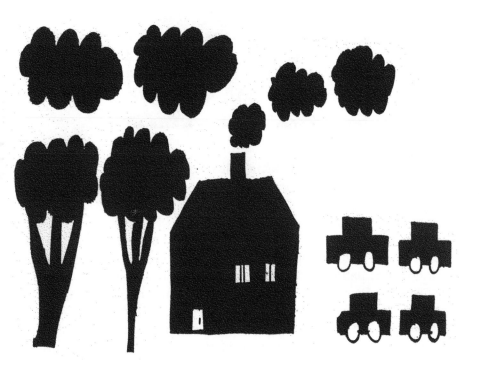

ISSUE NUMBER THREE

John Patrick McKenzie
ISSUE #3, March 1995

John Patrick McKenzie was born in the Philippines in 1962 and moved with his family to the United States in 1964. He joined Creativity Explored in 1989. His work has been exhibited nationally and internationally, including solo exhibitions at Monster Children Gallery, Surry Hills, Australia (2008) and Brett McDowell Gallery, Dunedin, New Zealand (2009). John was nominated for SFMOMA's prestigious SECA Art Award in 2012. His drawings are included in the permanent collections of Le MADmusée, Liège, Belgium, and abcd (art brut connaissance et diffusion), Paris, France.

LindaRonstadt you can not
~~catch~~ catch me

I like to say bad words to Linda Ronstadt
Linda Ronstadt is a white woman
I like to tease Linda Ronstadt

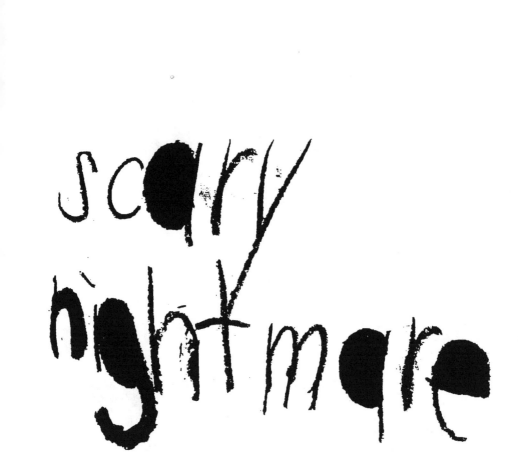

Linda Ronstadt
kicks
Spider—Man
between the
legs

John Patrick McKenzie turns into a bird
John Patrick McKenzie turns into a fish
John Patrick McKenzie turns into a dog

John Patrick McKenzie
turns into a werewolf

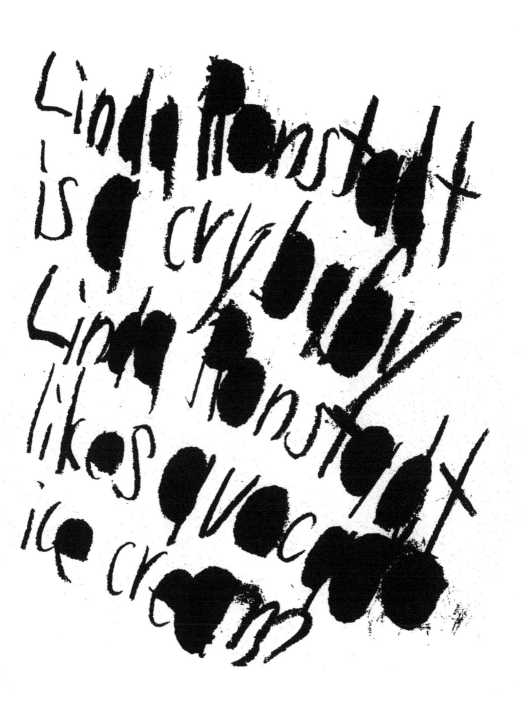

53

1940 I was born in the Philippines in 1962

in 1950 ▟▟▟▟▟▟▟▟▟▟

fifty-five chevies

ember 30, 1960 raza Christine Marie McKenzie

Gibb ▟▟▟▟▟▟ September 7,

e Gibb December 22, disco music
 jazz music

Sit ni Agcember 22, Filipino power

ibb March 5, Myrna Pama McKenzie raz
anson died in 1985, October 26, 1939 1983

1959 Karen Carpenter
 John Wayne was born in 1907
lepte mber 27, 1957 viva la raz, country mus

1935 Elvis Bresley died in 1977
 John Wayne died in 1979

I like to watch the news
my mother likes beef
my mother likes pork
my mother likes ham
my mother likes bacon
aminophyllin suppositories
for asthma attacks
6 years old
John Patrick McKenzie
October 17, 1962

Irish deaf children
Irish blind children
Japanese mute children
Swedish blind children
Swedish deaf children
Swedish mute children
Irish mute children
Italian blind children
chinese blind children
Italian deaf children
chinese deaf children
Italian mute children
Chinese mute children
Japanese blind children
Japanese deaf children

hurt no one

America no
I am a lover

stay with me Mexico,
god is watching us

I am a smoker I am a picker
I am a sinner

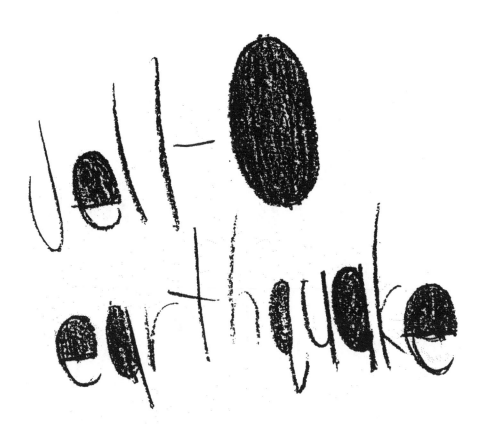

ham hocks
beans soup
Elvis Presley
Memphis
Tennessee

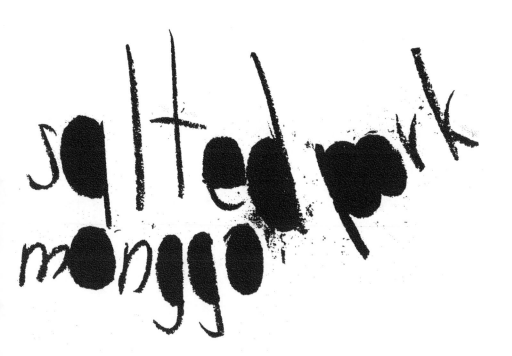

salted pork

monggol

John Patrick McKenzie

Interviewed by Harrell Fletcher

John: The people born in the '40s give me nightmares.

Harrell: What sort of nightmares?

J: They are not Asian and Latino.

H: What are they like?

J: White American. A white American woman drives a car and gets run over by some guy. She runs over some guy.

H: Then what happens?

J: The white American woman wears bright pink spike high heel shoes without panty hose.

H: And then what?

J: Oh yeah, she is cute. The white American woman runs over some guy.

H: She's cute?

J: Yeah, she don't like him and he don't like her.

H: Does he survive?

J: Nope. He died. He is a hitchhiker.

H: So, this was your nightmare?

J: Yeah, in 1987. I was 24. My father was 54 ... Oh, I remember. The white American woman drives a four-door American car.

H: Are you sure?

J: Yeah, she wears pink lipstick. She wears red high heel shoes.

H: I thought they were pink.

J: Yeah, pink.

H: Tell me about your early days, in Quezon City in the Philippines. Were you happy then?

J: I had a skateboard then.

H: You did? How old were you?

J: I was five years old.

H: What kind of skateboard was it?

J: Ummm... Filipino skateboard.

H: Wow. Could you do any tricks?

J: I went on the freeway.

H: Did you hold onto a car?

J: She don't know me.

H: Who?

J: The white American woman with the four-door car. She don't know me. The white American woman doesn't know I had the skateboard. I was five years old in the Philippines in 1967.

H: What did you do when you weren't riding your skateboard?

J: I had a radio. I was on top of the bridge drinking beer in the Philippines.

H: And you listened to the radio?

J: Yeah, it makes me gain weight, the radio, listening to music.

H: How does it work?

J: It makes me fat. Like the fattest man in the world.

H: You were the fattest man in the world? How'd you lose all that weight?

J: I drank salt water in the Philippines. I ride my skateboard on the beach. ... I don't like avocado ice cream. That's for Harrell. I like coffee ice cream because it is made of regular coffee grinds. I drink low fat milk.

H: Do you like to go to the supermarket?

J: I ride my skateboard on the freeway from San Francisco to New York.

H: What do you do when you get to New York?

J: I say bad words to John Lennon in the '80s, in 1980. Also, I don't like Yoko Ono.

H: What books do you like the best?

J: *Curious George.*

H: Why?

J: Because Curious George is a burglar. I like less government.

H: Why?

J: Because you could get away with murder. Harrell likes more government. I don't like Bill Clinton. He is a white American.

H: Are we friends?

J: No way. I want to dream my life away.

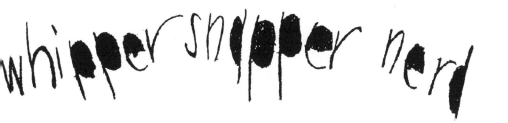

whipper snipper nerd

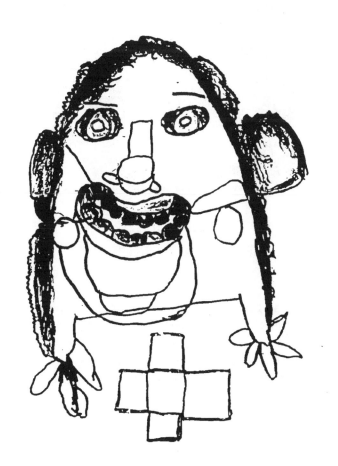

ISSUE NUMBER FOUR

Barbara Doehrman
ISSUE #4, November 1995

Barbara Doehrman was born in 1947 in San Francisco. An artist at Creativity Explored for more than 12 years, Barbara currently attends a recreation center for adults with developmental disabilities. Barbara has amassed an impressive collection of cat objects and images, and cats frequently appear in her artwork. Barbara is also a devoted fan of *The Brady Bunch*, another recurring subject in her writing, drawing and painting.

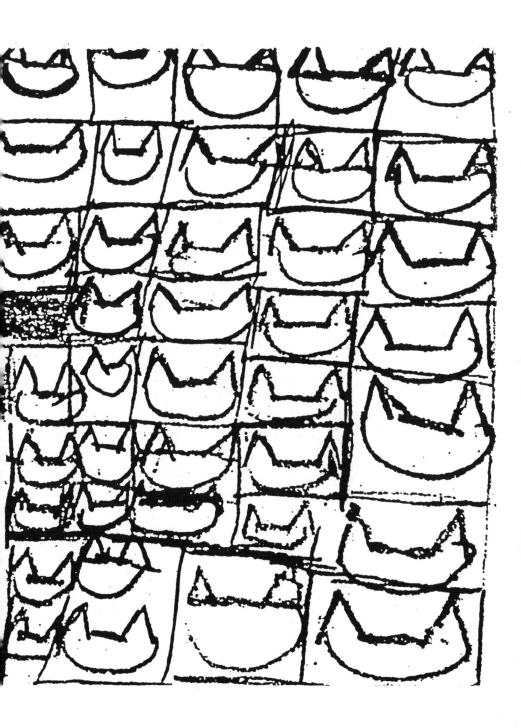

69

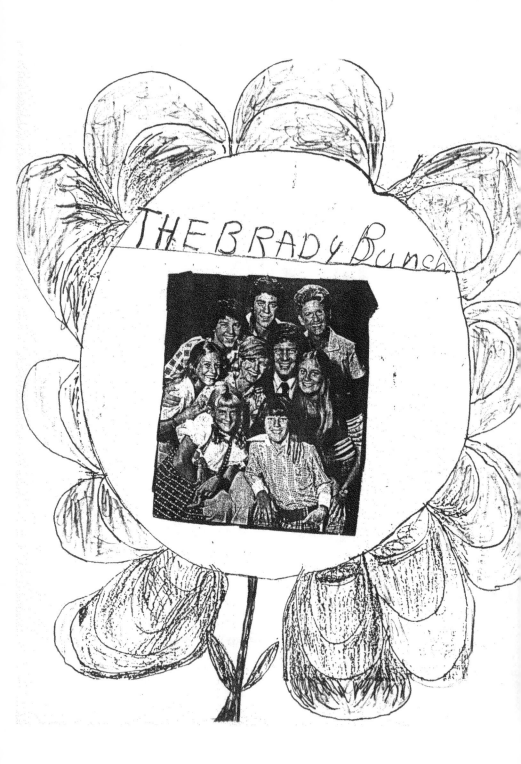

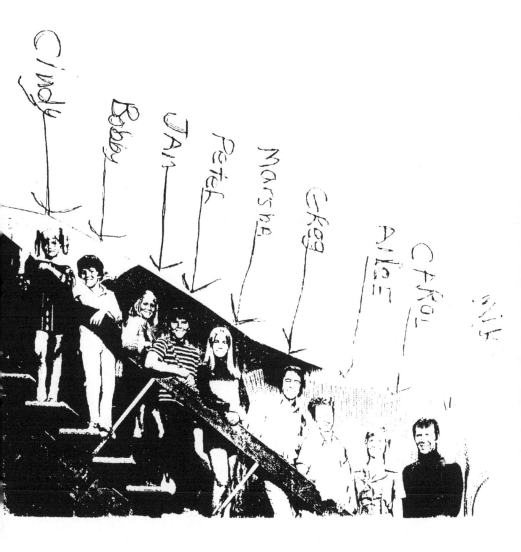

Cindy
Bobby
JAN
Peter
Marsha
Greg
Alice
CAROL
Mike

71

This is the fence the cats.
jump over in the back yard
This is where my cat missy
ran away.

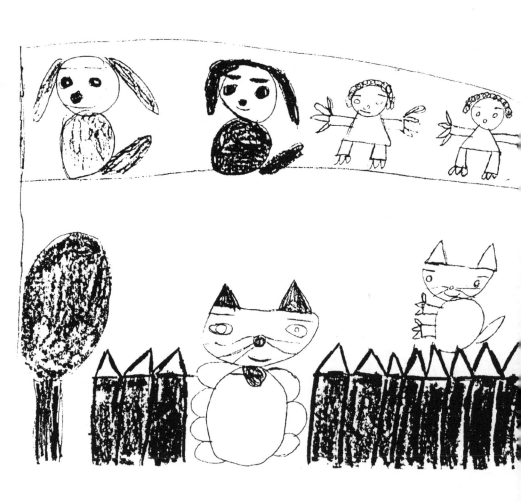

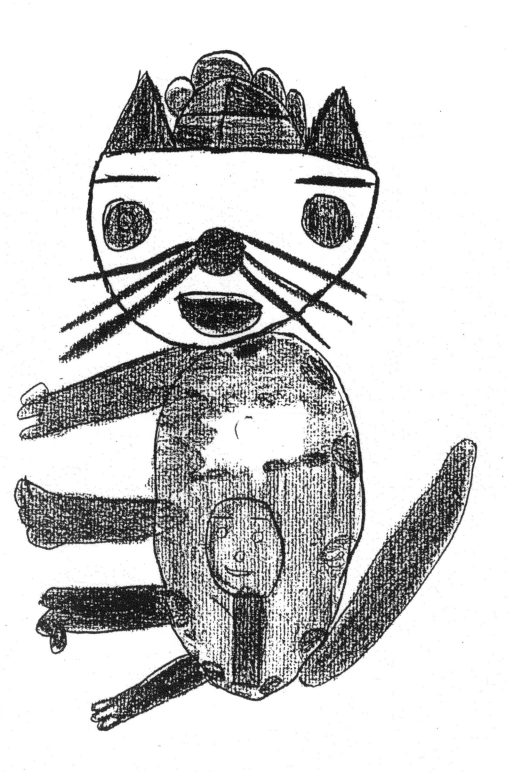

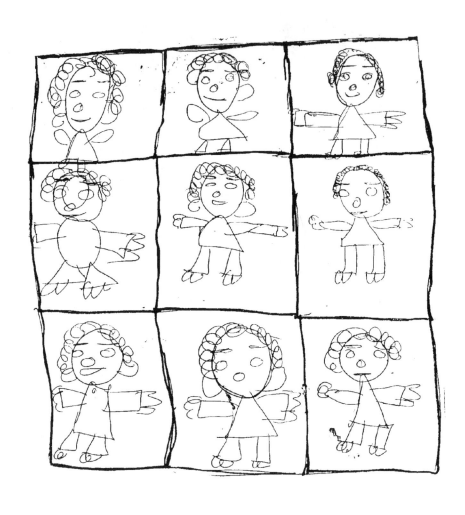

I was sick on Monday
I stayed home and watched
the BRAdy BUnch.

FlUFFy is In the Brady Bunch
Fluffy is the CAT of chnist,

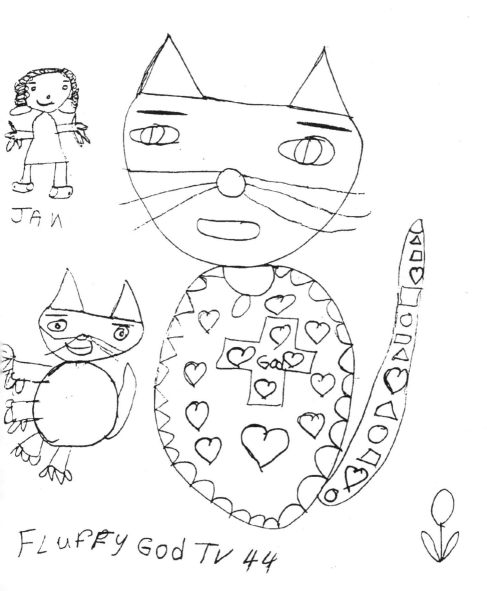

JAN

FLUFFY God TV 44

He came from space
CAt. He Looked at me
Like I was a cAt girl.
I meowed. I am a
cat girl. Look At
my eyes.

Angel cats are from space they come down from the SKY

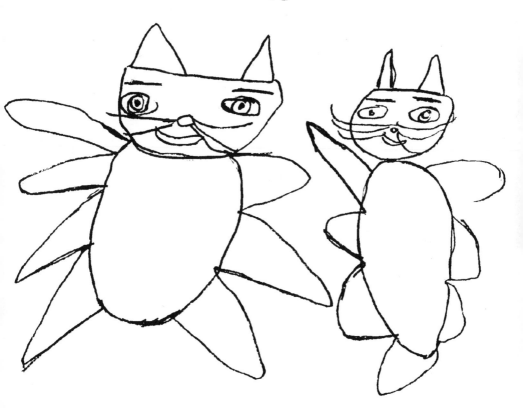

A Story of the Brady Bunch.

Barbra Dochrman and michael Bernard Loggins L
to see it on Television Set I Think That its Kind of
for generations. Barbra and michael liked the Par
in lots of Trouble. Michael Saw it yesterday on
window to go And Put the letter that She had t
The Father of the year. When She got back in
ski trip with her family. Ruthie what do you
Children gets in lots of trouble. that what I l
Sometimes in our lives. David like it when M
Get the house Strighten out and keep it nice an
Bird For a pet And Feed the Bird And ta
over the house And the Bird Flew out of t
mom and Dad That Tiger had made the
the door into the yard he climbed up the tr
the bird down And bobby took the bird in th
dog tiger But he got over being Angry wi
Brady, mike told tiger that he was a bad
ate his food He went outside in the Backwar
Barbra favorite Show that they love the Bes
When michael Bernard Loggins wrote this s
Barbra. The End of this story.

to watch The Brady Bunch comedy show Because its Fun
ted The Brady Bunch on Funny show That had been on
when Jan was up to Jokes And Tricks again She got
ursday June 6-22-1989. marcia went out of The
end to the news Paper printer in The mail Box For
e had got in Trouble And She couldnt go on any
e about The Brady Bunch? I like when the
about the Brady Bunch. we do get in trouble
mike Brady tells the children to go to work And
eat. Barbra like When Bobby try to keep the
care of it But When tiger Chase The Bird all
window Bobby had a fit he went to tell his
d go out of the window so bobby went out
to get the bird down And when he Finally got.
ouse into his room. Bobby was Angry with his
tiger. Tiger got scolded by carol Brady And mr
? Bad dog you are tiger. And tiger Barked And
Brady Bunch is one of michaels Ruthis and

Friday June 6 month 23. Day 1989.
t down. This is a copy that michael made for

Barbara Doehrman

Interviewed by Elizabeth Meyer

Elizabeth: You know how we're putting together a magazine of your work?

Barbara: About *The Brady Bunch*?

E: Yeah, and your other stuff too.

B: OK, let me draw a dog and a cat for it, too. The cat's name is Fluffy.

E: From *The Brady Bunch*?

B: Yeah, and a dog named Tiger, too.

E: How come you like *The Brady Bunch* so much?

B: Oh, I don't know... but the movie's coming out! It's out!

E: Tell me about an episode of the TV show you like.

B: I like the one where Peter is playing ball in the house. Jan said, "Peter don't bounce that ball in the house." And the mom came home and said, "Someone broke the... the..."

E: The vase?

B: You got it! You got it! That's it right there. The mom came home, and she blew up.

E: Yeah, I guess there was a lesson in that one, huh?

B: Yeah.

E: Do you have any other stories?

B: One about Mary and Jesus. He was born on Christmas day. I wish I had brought the bible with me. I forgot it.

E: Do you bring it with you sometimes?

B: Uh-huh.

E: Yeah, I've seen a lot of images of Jesus in your work.

B: That's right, and angel cats, too.

E: Were there cats in the bible?

B: Yep.

E: Where?

B: There were 99 cats, and one was lost—it was a Siamese.

E: How did you get so into cats?

B: They're in my mind. I've got them all over my room, too—two kitty-cat calendars, cat books, four of them, stuffed animal cats and a *Brady Bunch* record and two Barbie dolls.

E: What's this one about?

B: The rainstorm. Two trees got knocked down. This one's about my friend Ricky. We were supposed to go on a date.

E: But you couldn't because of the rain?

B: Yeah.

E: Where were you going to go?

B: To see our friend.

E: Not to *The Brady Bunch Movie*?

B: That's next Sunday. But we might not go.

E: What? Why not?

B: I might go to a square dance instead.

E: Do you know how to square dance?

B: Yeah. And I already have the skirt.

E: What does it look like?

B: It's long and it's got the rainbow. I love rainbows... and rainbow cats.

E: What are rainbow cats?

B: You'll see. I'll draw you one sometime.

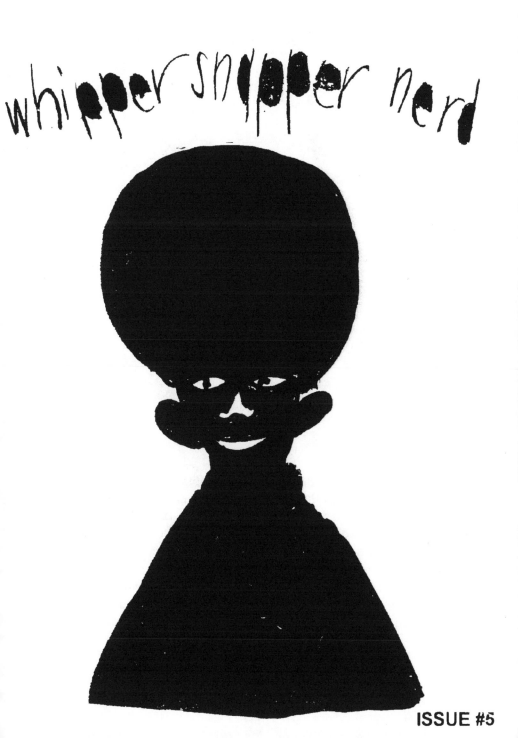

whipper snipper nerd

ISSUE #5

David Jarvey
ISSUE #5, December 1996

David Jarvey, also known as Ricky Nelson, Jr., Captain Christopher Pike, and Elvis, was born in 1957 in Tokyo, Japan to career army parents. He moved to the Bay Area when he was 12 years old. From 1984 to 2002, David made art at Creativity Explored, where he worked in a variety of media including drawings, paintings, textiles, and sculptures. He collaborated on and starred in several videos produced at Creativity Explored, including *The Final Frontier*, which screened as an installation at Yerba Buena Center for the Arts and aired on Oregon Public Broadcasting. A dedicated musician, David often played guitar on the corner of 16th Street and Mission in San Francisco. He passed away in 2006.

THIS IS THE NEW ONE.
THE NEW EPISODE.
THIS IS ABOUT ME

CHRISTOPER PIKE,
STAR SHIP CAPTAIN,
HIGHER +HAN All
+hE CAPTAINS.

WE ARE HEADING +o
+he forbidden WORlD
+o TALOS IV.

TALOGIAN

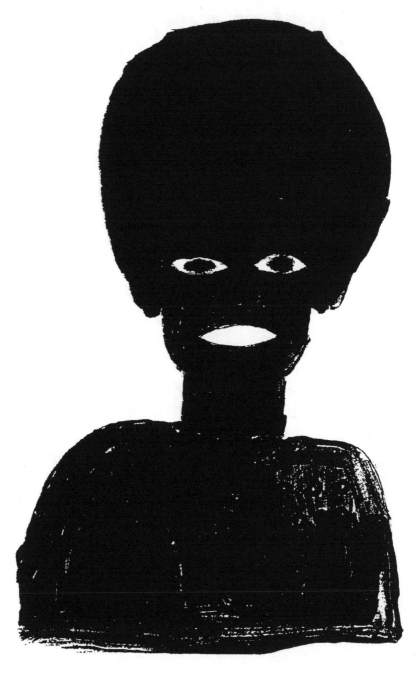

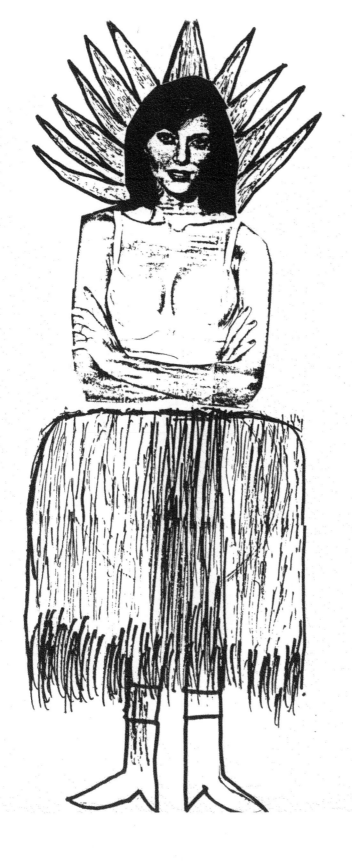

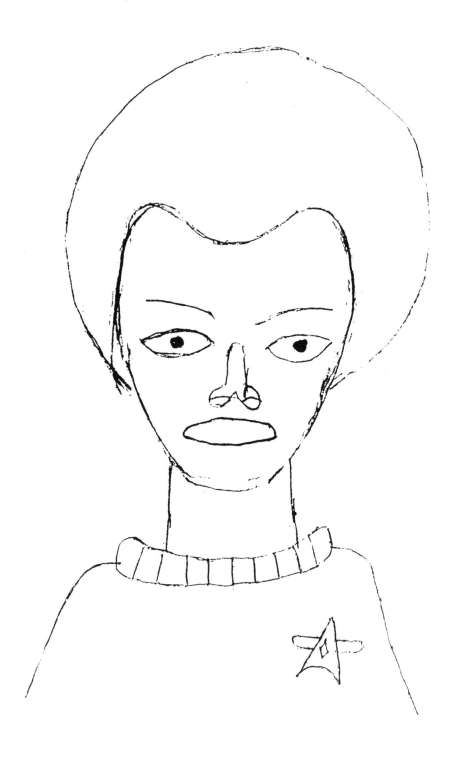

Japanese Star Trek

Space, the final frontier. This is the Starship Enterprise.
Four year mission.
Space, the final frontier. This is the Starship Enterprise.
Each planet, no man gone before.

I was the captain, the original one. I am Christopher Pike, Starship Captain, higher than all the captains.

This is about my crew members. I was born in Japan, in Tokyo, on June 20, 1957. I came from a Japanese family. We ate crabs and shrimp salad and fried rice with shrimps inside of it. Crab salad is good... and lobsters.

Tuesday Weld is a Japanese female. The Talosians are all Japanese too. I fall in love with the Japanese female. There were two of her -- a clone. She is sexy looking. She is so beautiful. She falls in love with Christopher Pike, Starship Captain. She falls in love with me.

Scotty, the engineer, is Japanese. Lt. Uhura, she is Japanese. Dr. McCoy is Japanese. They are on the Enterprise headed to the next federation. My crew members are Japanese Data, Japanese Deanna and Japanese Beverly. Japanese Patrick Stewart plays the new captain. Jean Luc Picard is Japanese too.

THESE ARE
THE ONES
IN MY
DREAMS.
THE NEW
CHRISTOPHER
PIKE IS
ME. FALL

IN LOVE
WITH THE
TWO TUESDAYS
ALSO CALLED
VENA.

F—RACERBACK
EMMA BRA

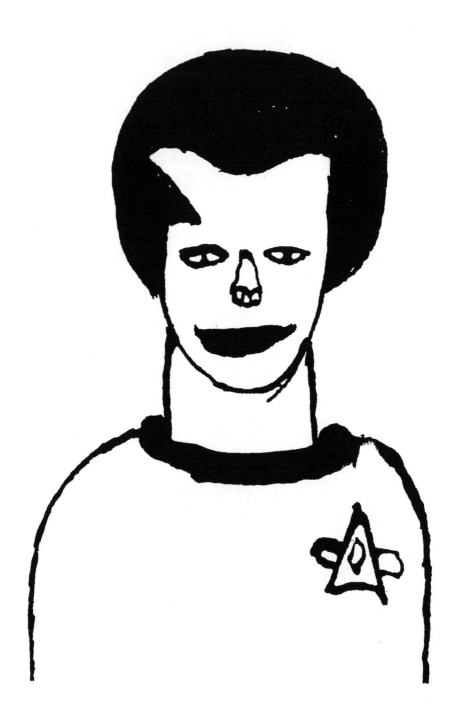

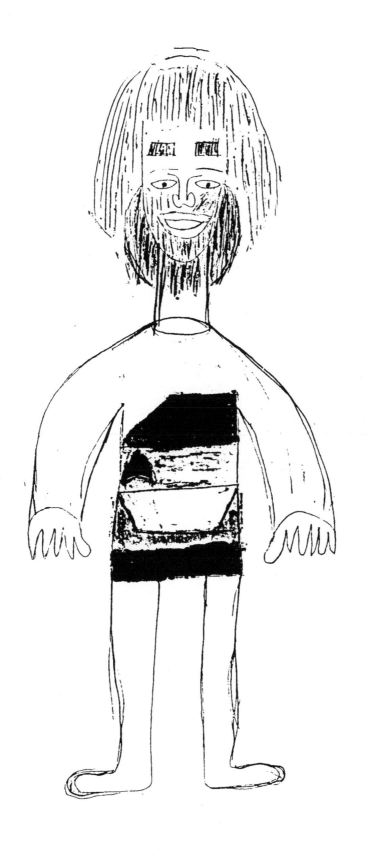

Scientists have a wildly ambitious plan to

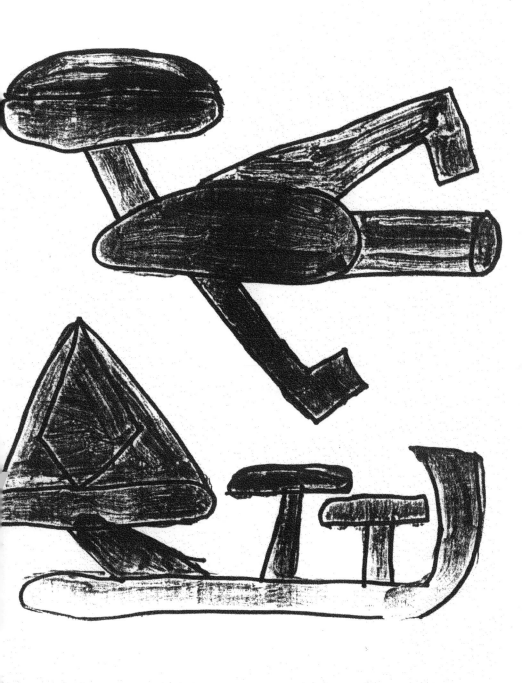

Star Trek: The Three Stooges

Three Datas. O.K.

Three of Diana Troi, Counselor Troi.

Three of her. They are androids.

Three of Beverly. They are androids.

William Riker. Three of him are androids.

Jean Luc Picard, Starship Captain.

Three of him... ANDROIDS!

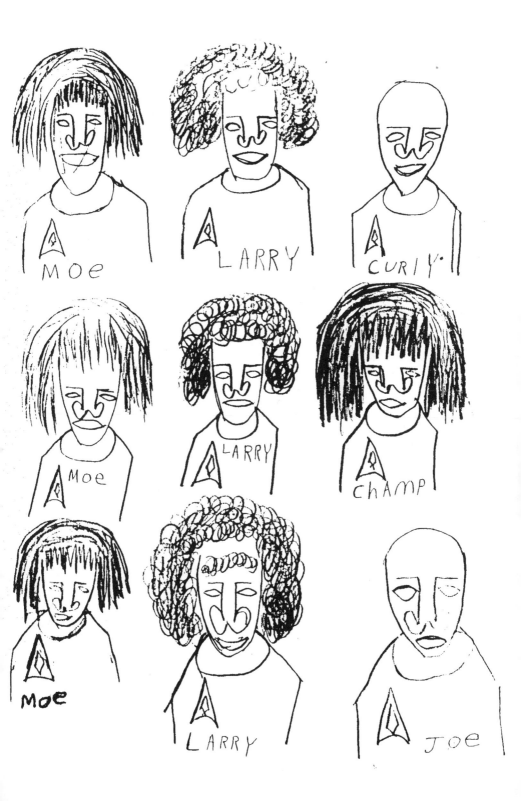

SANTA CIA

ME — CH

STAR

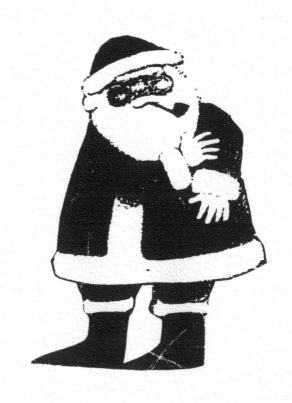

S IS REAIIY

RISTOPHER PIKE

SHIP CAPTAIN.

David Jarvey (aka Ricky Nelson, Jr.)
Interviewed by Elizabeth Meyer and Harrell Fletcher

Elizabeth: So, how'd you get the name Ricky Nelson, Jr.?

Ricky: My father, Ricky Nelson, he named me after him. I have my father's guitar. He taught me everything. Then, something happened. He went to the state fair. The pilot had been drinking liquor on the airplane. He hit right down to the cement and blew up with my father and someone else.

E: What was your father like?

R: My father took me to the state fair. That's where I play in real life the songs he taught me, *Dream Lover, I'm the Only One, Yes Sir That's My Baby, Hello Mary Lou, I'm a Traveling Man.*

E: When were you born?

R: I don't know what year it was, it's in my record. I was born in Japan. They had a place like a sauna in Tokyo, Japan. I had a group band. I named it "State Fair Double Hit." We performed back in the '60s and '70s. I had a father back there in Japan. He's Japanese. He's a movie star, like me.

E: And where did you go after Japan?

R: I was the original captain, Christopher Pike, of the Starship Enterprise. I took the starship to Talos IV, the Forbidden Zone. I talked to the leader of the Talosians. I asked if I could marry Tuesday Weld. She has blonde hair. She lives on Talos IV. Tuesday Weld and I fall in love. I was dreaming about myself. I dreamed about Tuesday Weld. She wants me so bad.

E: Then what happened?

R: We traveled in space. I hired a new captain. He is Jean Luc Picard. I hired him to be the new starship captain. This happens in space, the final frontier, the Starship Enterprise, our four-year mission, each planet, no man gone ... look out! Anything happens in space.

Harrell: Tell me about the life forms in space.

R: They are on the other ship.

H: What do they look like?

R: I don't know, like creatures. The Talosians are from my childhood. They did something. They asked me to marry Tuesday Weld. They punished me. I did not listen to them.

H: How did they punish you?

R: They put me in a trap in a zoo. My face got burned. They did bad things to me. They want me to fall in love with Tuesday Weld.

H: Don't you want to fall in love with her?

R: I was going to say something nice. I was going to tell them I'd stay there for good. I want to live there.

H: What's it like there?

R: Nice place. They ask me a lot of questions. Their leader, he asked me some questions. If I sign the paper, I can stay there. I'm going to say yes, stay there for the rest of my whole life.

H: It must be lunchtime. What are you having today?

R: I don't know yet... bologna, toast, an orange, lemon and a soda.

whipper snipper nerd

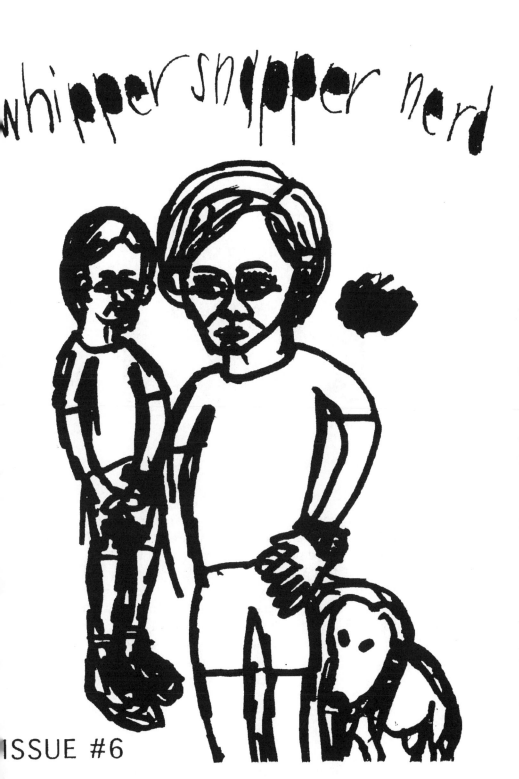

ISSUE #6

Andrew Li
ISSUE #6, October 1997

Andrew Li was born in Shanghai, China in 1962 and moved to the United States with his family in 1980. He currently lives with his parents in San Francisco and has worked at Creativity Explored since 1990. Andrew has shown his work nationally and internationally in both group and solo exhibitions, including *Bay Area Now 2* at Yerba Buena Center for the Arts, San Francisco (1999); Funabashi Cure Gallery, Funabashi, Japan (2003); Jack Fischer Gallery, San Francisco (2009); Boston University College of Fine Arts—Sherman Gallery (2011); art museum VERSI, Yongin-si, Gyeonggi-do, Korea (2016); and the Outsider Art Fair, New York (2017).

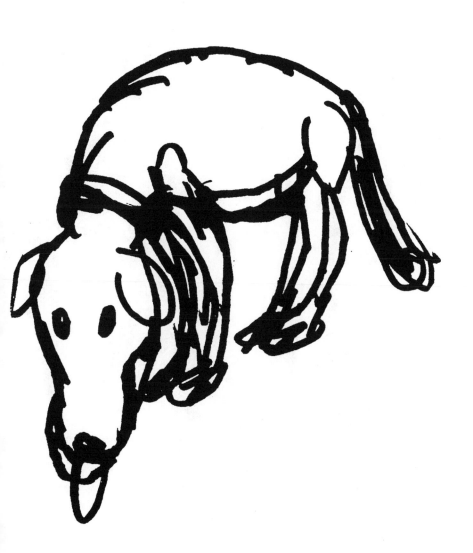

MADE IN U.S.A.

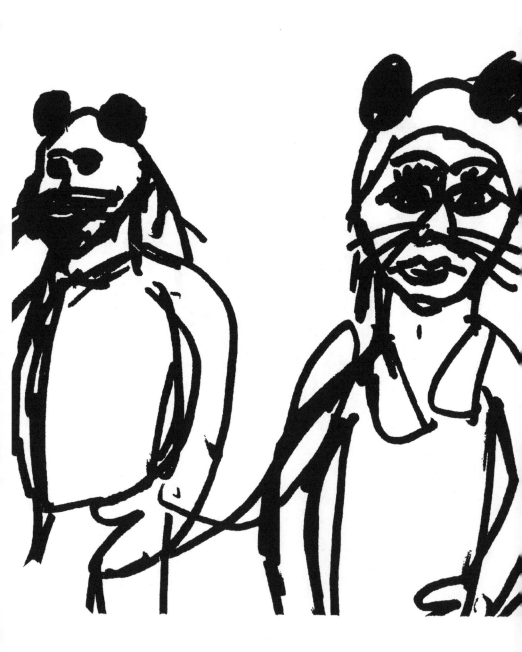

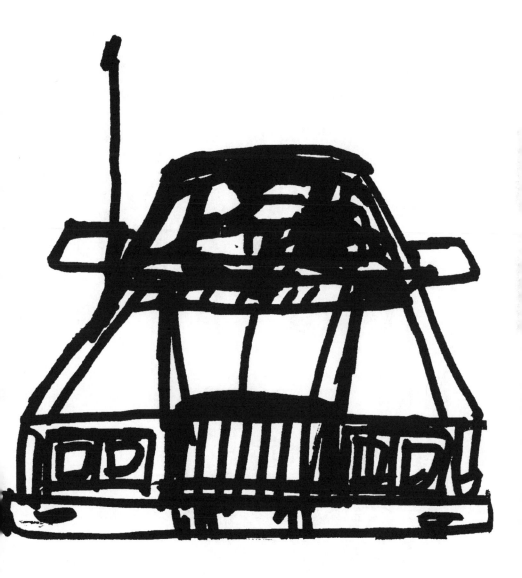

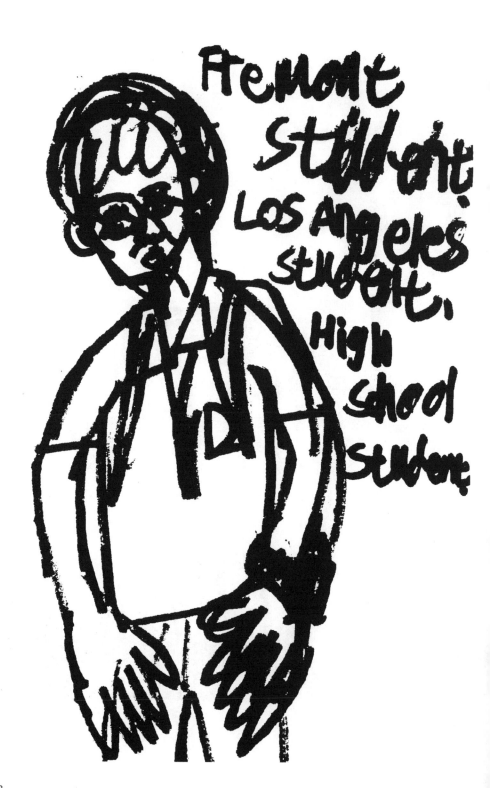

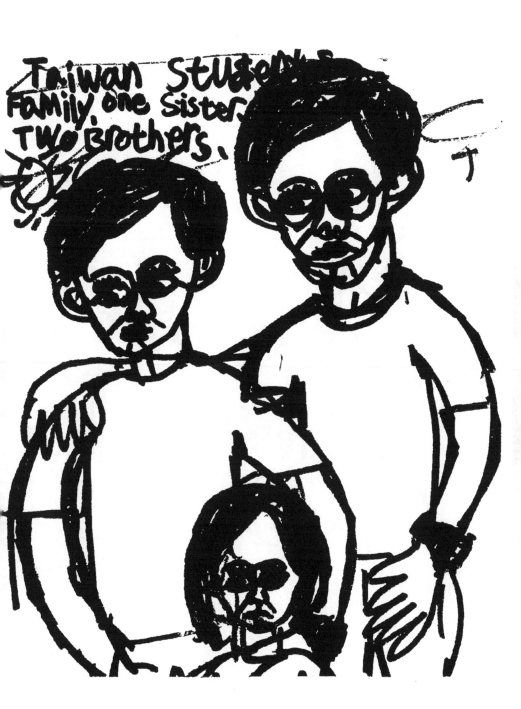

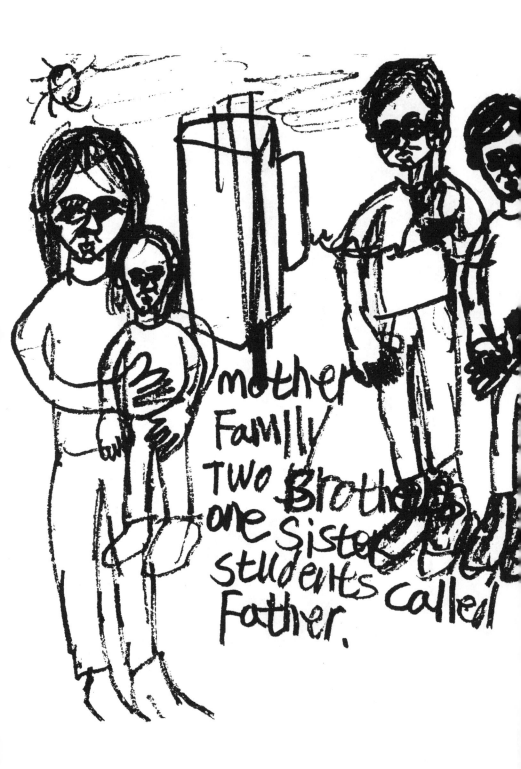

FLORIDA dog ang cat

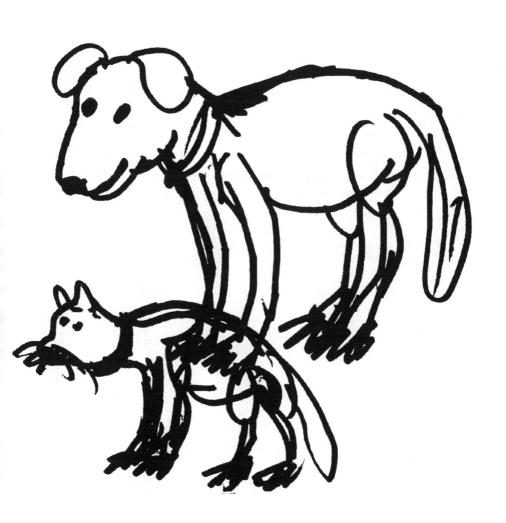

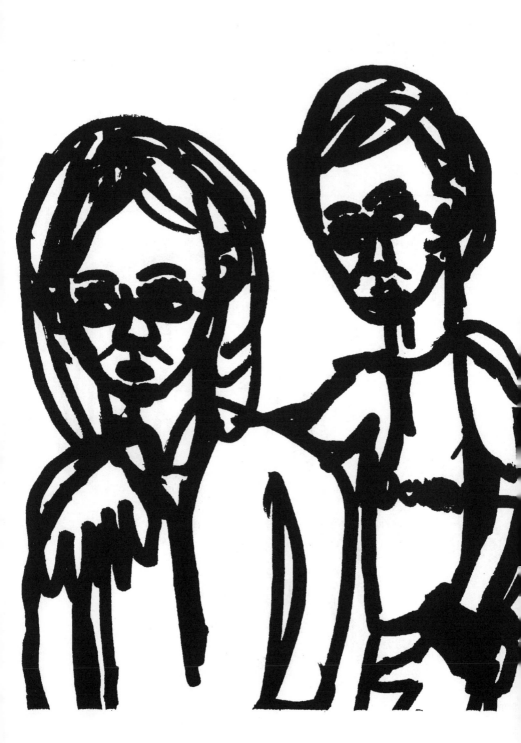

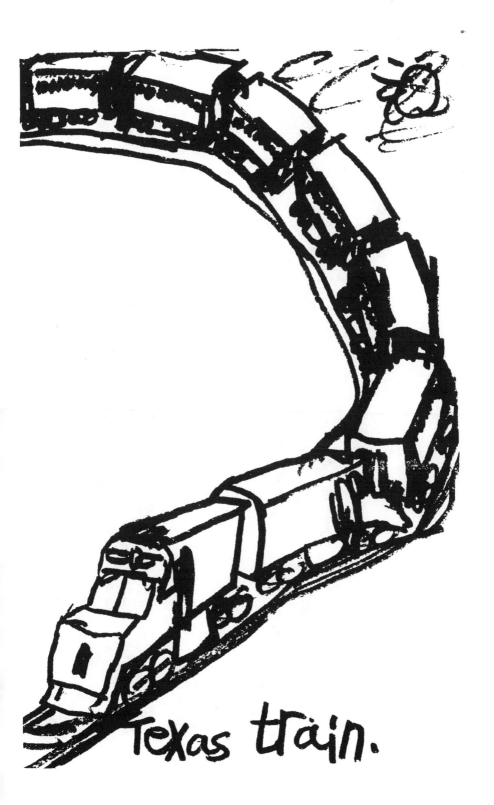

Texas train.

FLORIDA StUDEntS Black Watches

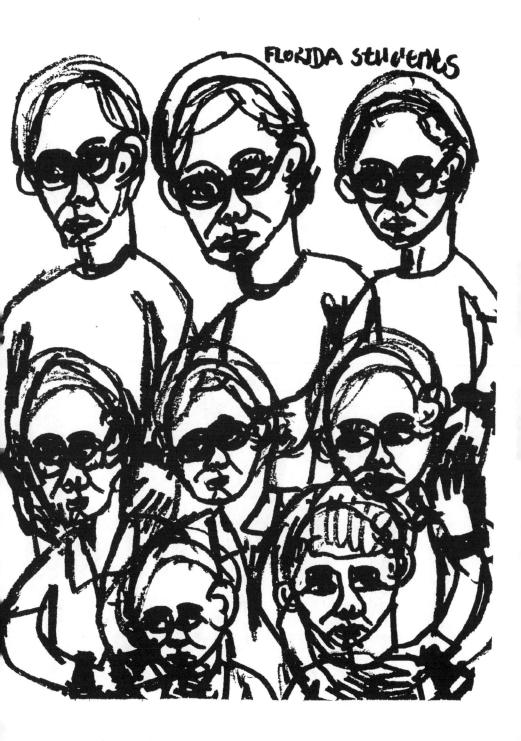

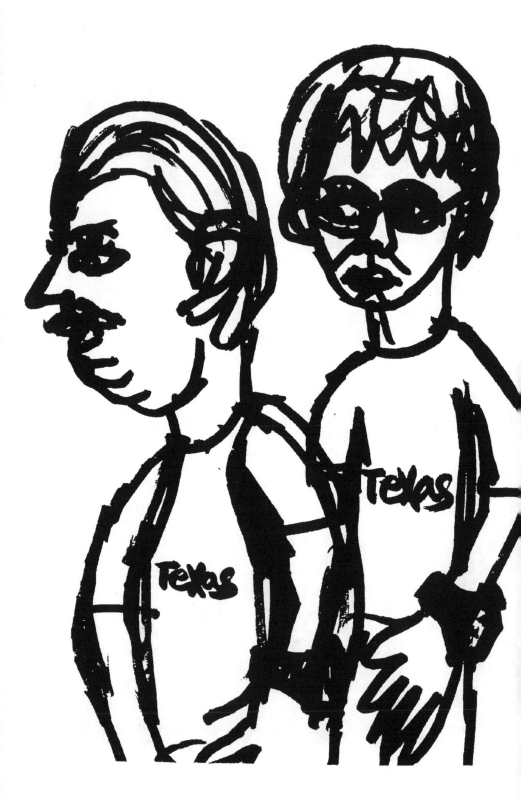

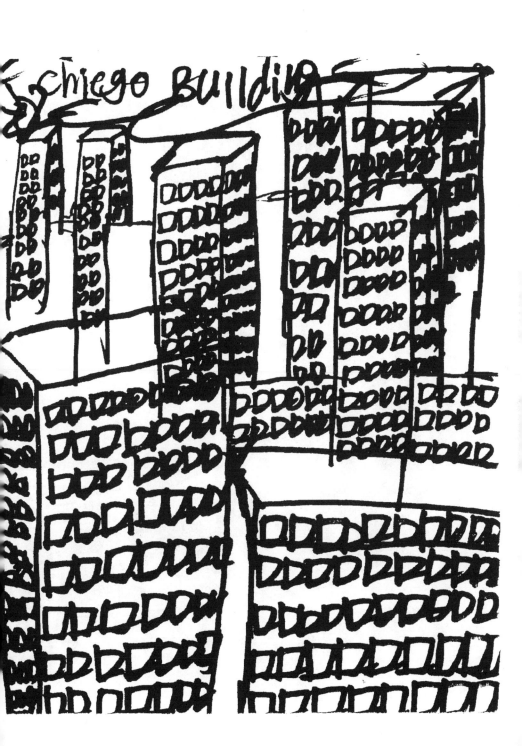

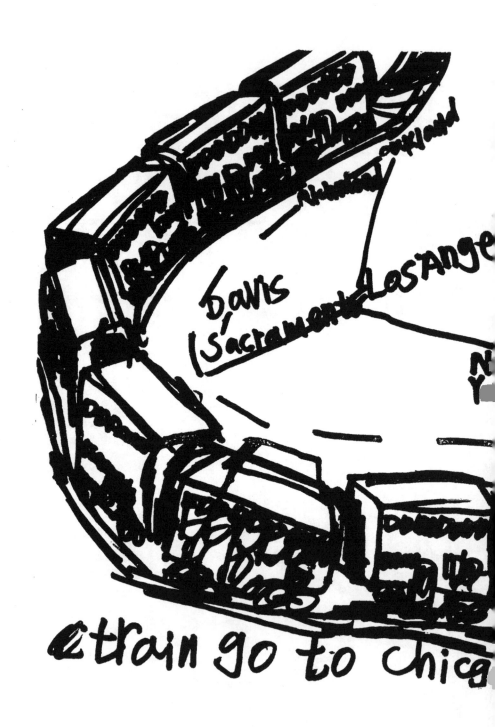

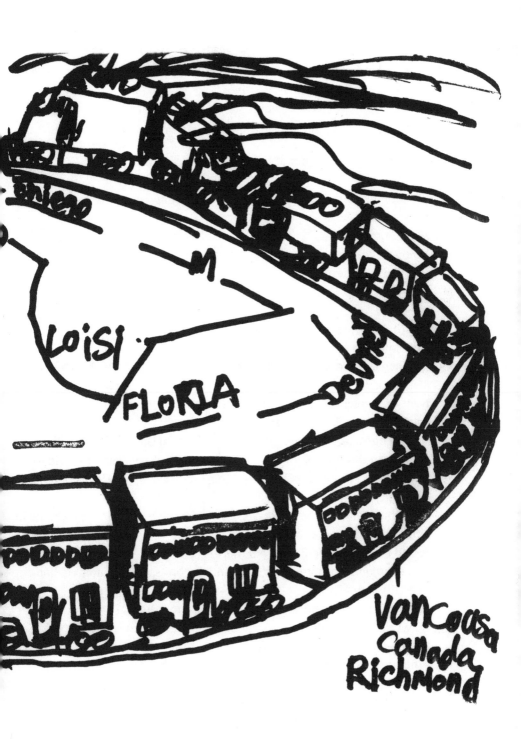

Andrew Li
Interviewed by Harrell Fletcher

Harrell: A lot of your work is about places—various cities and countries. Which
of them have you personally visited?

Andrew: Vancouver, Florida, Los Angeles, New York, San Francisco, Thousand
Oaks, Camarillo, Louisiana, China, Japan, Denver.

H: You were born in China and came to the U.S. when you were seventeen.
What do you remember about China?

A: I don't know.

H: Sometimes you make your drawings into books. How long have you
been making books?

A: A long time.

H: What do you think about us making a little book about your work? Do
you like that idea?

A: Yeah.

Interview with Andrew's mom, Catherine

H: How long has Andrew been drawing?

Catherine: Since childhood. In China he mostly drew people. Now he seems to
like cars quite a bit. There weren't as many cars in China. We took a
train to Denver in 1988. He likes drawing trains.

H: Andrew has really traveled a lot.

C: Yes, he has been to Vancouver every Memorial Day for the past three
years, and this last May we went to Tampa. Andrew likes cities. He isn't
interested in mountains or trees. I think it is because he loves people.

H: What city are you from in China?

C: Shanghai, which is a very big city, but there were no special programs for
handicapped people.

H: So did he go to a regular school there?

C: Yes, everyone was integrated, but Andrew has special needs. He had
difficulty there.

H: I understand that Andrew has a job. What does he do?

C: He works at a Goodwill store. He helps sort the clothes and put yellow
and green tags on them. He takes the bus there on his own.

H: What does Andrew do at home?

C: He is a daydreamer. He likes to watch TV. He also writes a daily journal
about the people he meets and the things he does.

H: Do you have pets at home?

C: We have never had cats or dogs, though Andrew draws them very well.
He also draws ducks. They look like they are moving with their heads

all going different directions. We never had any pet ducks either. We did have a hamster about ten years ago.

H: I'm very impressed with Andrew's drawings. He does them so quickly but with great accuracy.

C: Andrew has excellent observation skills. I took him to a relative's house once. He seemed distracted, like he wasn't paying any attention, but then we went home, and he drew the house where we had been, and it looked just like it. Every window and door was in exactly the right place.

whipper snipper nerd

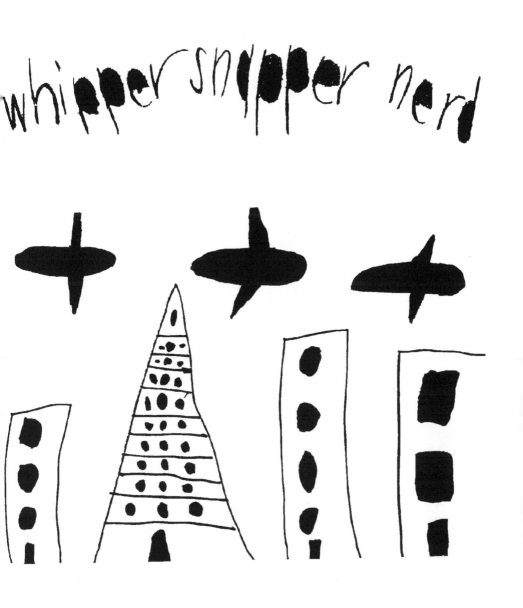

ISSUE NUMBER SEVEN

Robert Margolis
ISSUE #7, April 1998

Robert Margolis was born in San Francisco in 1951 and worked at Creativity Explored from 1984 to 2006. Robert has traveled extensively, most often with his now-deceased father, throughout the United States and Europe. Robert's trips have inspired much of his writing and drawing. His work has been included in several exhibitions at Creativity Explored including *Saints and Spirits*, *Contextual*, and *Aliens The Green Ones*.

Dear Alaska airlines
 Can you mail me
a free round trip to
Portland Oregon?.
I want to go on
a friday morning
and come back on
same day friday
afternoon ●
 Thank you
Robert Mangols

WELCOME TO MARS THE PLANET

ROCKET BLASTING
OFF TO THE MOON
WITH A THOUSAND
STRAUNATS ALLMOST
THE SAME LIKE
AN AIRLINER
IT GOES
200 MILES
AN HOUR THATS VERY
FAST

I sold a painting and went downtown, took bart
for a 30 minuts ride in the small p
for one person, I enjoyed that ri
to the bart station, took bart to San F
get paid enough for m

BART

ncord, took the taxi to the airport, went
2 around Concord that Costs $35.45
very much. I took the taxi back
vcisco. I hope i go again if i
rt work.

TAXI

CITY
OF CONCORD

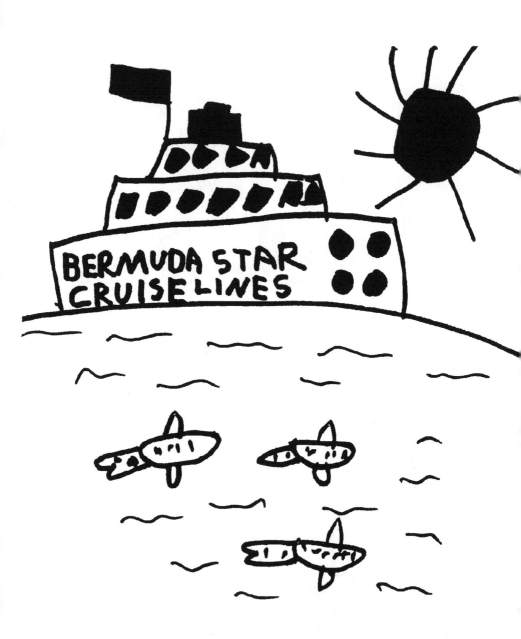

MY FATHER AND MY AUNT TOOK ME TO MEXICO
4-88 BY SHIP FROM SAN DIEGO TO CABO SAN LUCAS,
MAZATLAN, PUERTO VALARTA, WE FLEW INTO SAN DIEGO
AND WENT TO THE PIER IN A BUS
WE ATE BREAKFAST, LUNCH, DINNER ON THE
BOAT WE ENJOYED IT VERY MUCH.

PUERTO VALARTA

MAZATLAN

CABO SAN LUCAS

SUNDAY 8-17-86

I went to Alaska with my fathe
and my aunt, I watched the make
believe horse races, I enjoyed it
very much, I looked around
and walked around the boat
I saw all different things on
the trip ice-bergs, stores,
houses, buildings, cars
passing, by, people,
polar, bears,
whales.

I went for a ride in the seaplane at pier 39 the ride lasts 30 minutes it costs 89.00 to go for a ride I enjoyed it very much

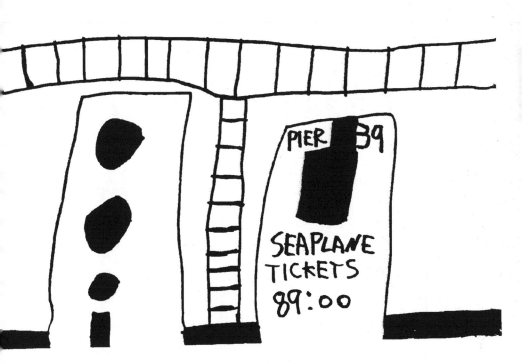

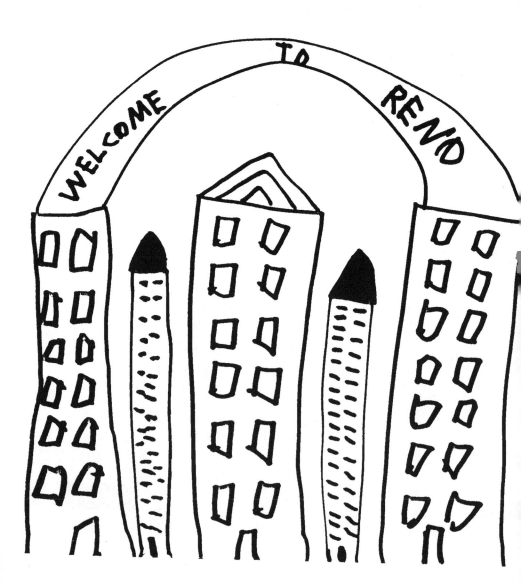

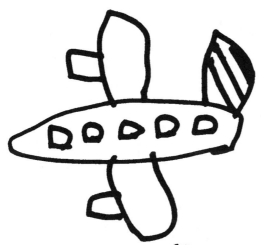

on Wednesday 8-12-92
I went to Reno by myself,
I sold another painting,
I few in and I flew out,
I saw Reno from the air.

I enjoyed the ride
very much.

"This is Daly City bart
gateway to the peninsula
a lot of people take bart
to the east bay to
work every day

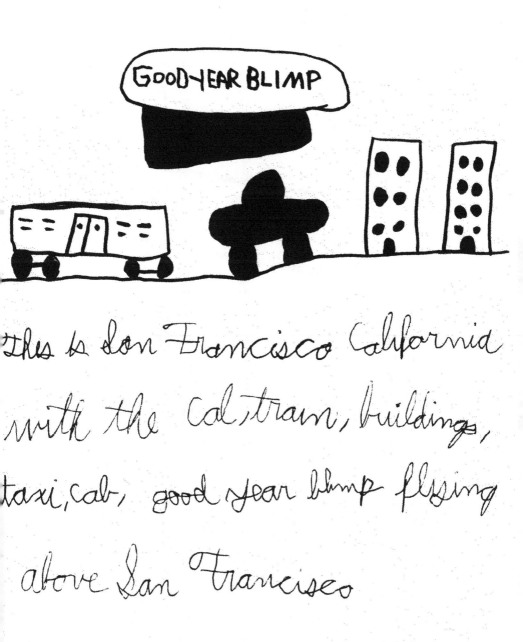

This is San Francisco California
with the Caltrain, buildings,
taxi,cab, ~~good~~ year blimp flying
above San Francisco

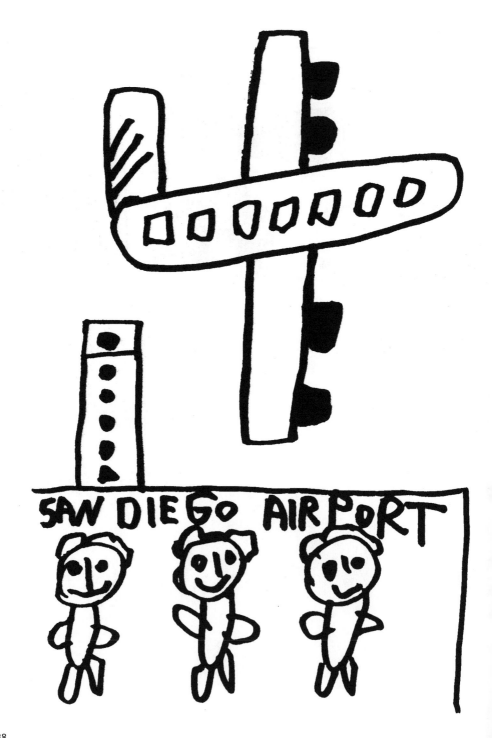

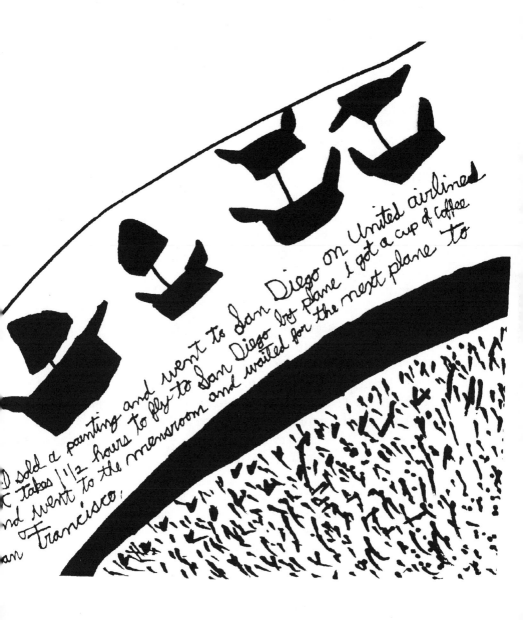

I sold a painting and went to San Diego on United airlines

It takes 1 1/2 hours to fly to San Diego by plane I got a cup of coffee

and went to the mensroom and waited for the next plane to

San Francisco.

Robert Margolis
Interviewed by Harrell Fletcher and Elizabeth Meyer

Harrell: Where was your last trip?

Robert: It was to Laughlin Nevada, with no directions.

Elizabeth: How did you get there?

R: I went to Burbank by plane and took a van from the airport.

E: What did you do when you got there?

R: Played the gambling machines and went sightseeing. I went for a riverboat ride to a hotel to play the slot machines.

H: How was it?

R: It was fun. I enjoyed it.

H: How did you get back?

R: I took a van to the Burbank airport. From there I took United Airlines to San Francisco.

H: What did you see from the plane?

R: I saw nothing. It was dark. I saw mountains. The ocean. The San Francisco skyline.

H: Tell us about your favorite trip.

R: All the trips are my favorite.

H: Could you tell us about another one?

R: I went to Alaska. Anchorage to Vancouver by ship.

H: How did you get to Anchorage?

R: Western Airlines from San Francisco with my father and my aunt.

E: What did you see in Alaska?

R: Glaciers. Towns. Stores. Mountains.

H: How was the food on the boat?

R: They had American food on the boat.

E: What kind of food is American food?

R: Fried fish. Fried steak. White rice with butter. Macaroni and cheese. We had brandy and water before dinner time in the hotel with my father and my aunt. We listened to the radio. ... Have you ever been on a cruise?

E: No, do you recommend that I go on one?

R: I am not sure.

H: How many countries have you visited?

R: Holland, France, Germany, Portugal, Spain, London.

H: What was it like in London?

R: It was pretty. That's what it was like. Once in a while something comes up that we are not expecting. That is life. That is true.

H: How does that make you feel?

R: That makes me feel terrible when something happens unexpectedly.

E: How do you get to Creativity Explored in the morning?

R: I take the bus by myself. I stop at Post and Fillmore Deli-Grocery in the morning to get a coffee. If a man saves dimes and nickels for six months, how many dollars will he have at the end of six months?

E: It depends on how many dimes and nickels.

R: If you had 100 dimes and 100 nickels at the end of six months.

E: I think that would be $15.

R: That is a good guess.

H: Is that right?

R: I do not know. But it is a good guess.

E: What do you like to wear while you're traveling?

R: New clothing.

E: What would you say are the most important things to bring on a trip?

R: Shaving equipment, toothbrush, toothpaste, deodorant, change of clothes.

E: I think good shoes are important too, so you don't get too worn out. Do you ever get tired from all your traveling?

R: No, I never get tired.

H: Never?

R: No, never.

whipper snapper nerd

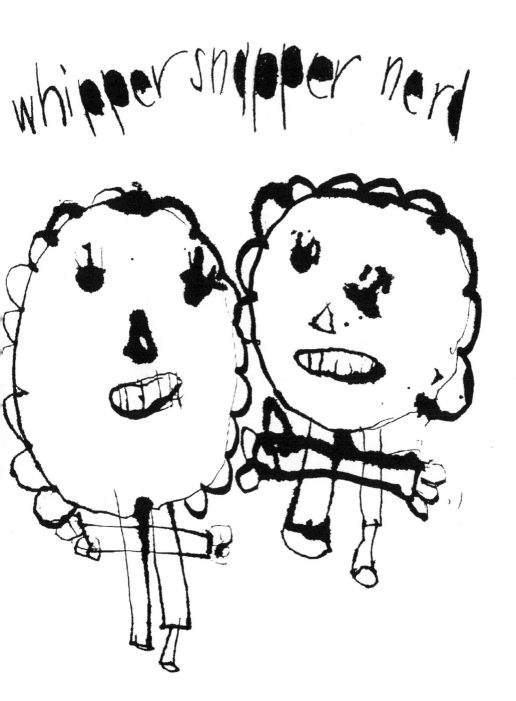

ISSUE #8

Diane Scaccalosi
ISSUE #8, May 1998

Diane Scaccalosi was born in San Francisco in 1944 and worked at Creativity Explored from 1990 to 2014. Her artwork evolved over time from being primarily figure-based to mostly abstract. Diane's work has been shown by Track 16 Gallery, Santa Monica (2004); *Outside In: The Art of Inclusion* at Crawford Art Gallery, Cork, Ireland (2013); and several exhibitions at Creativity Explored.

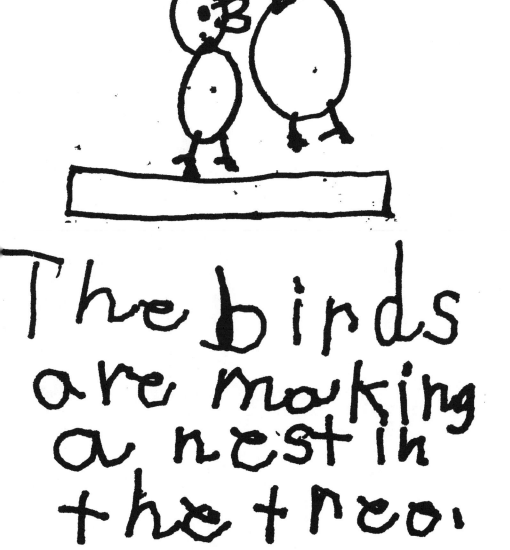

The birds
are making
a nest in
the tree.

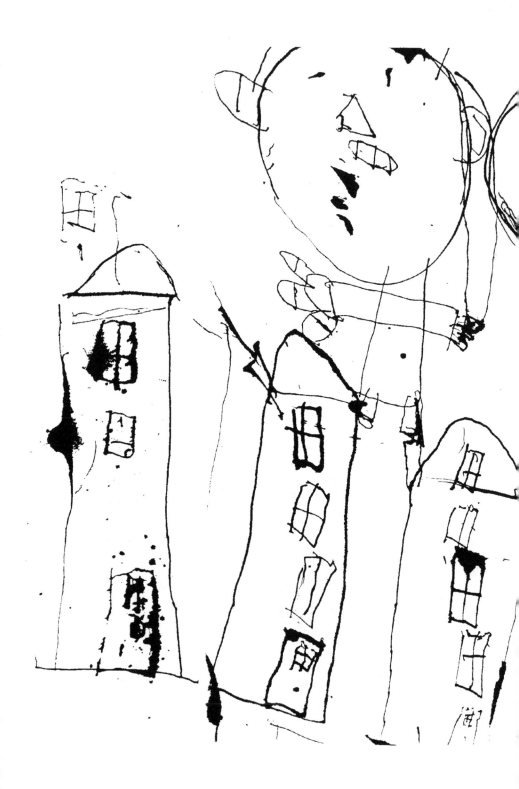

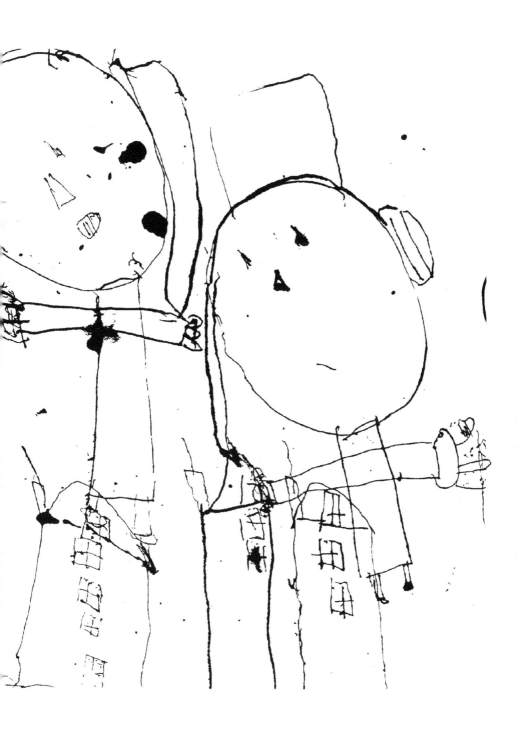

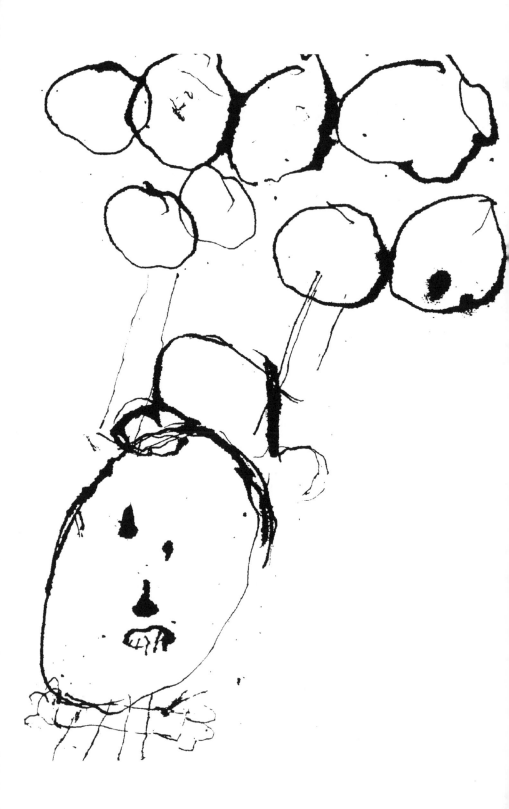

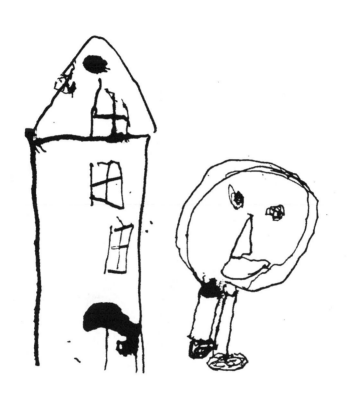

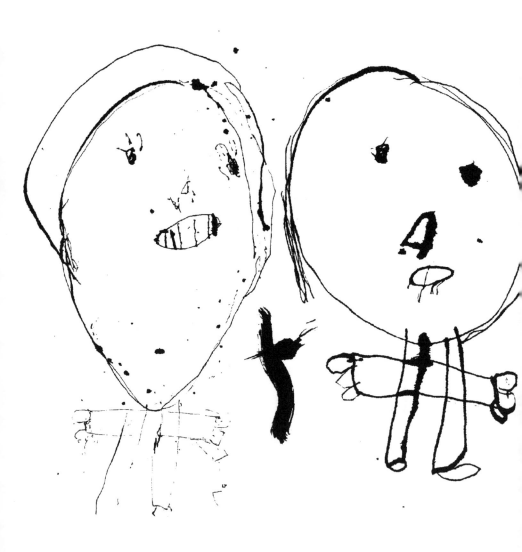

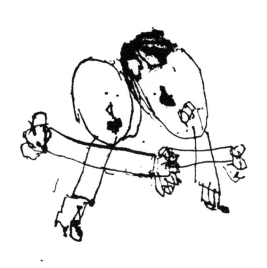

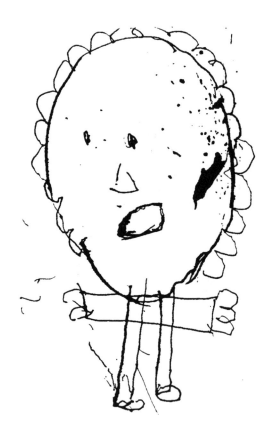

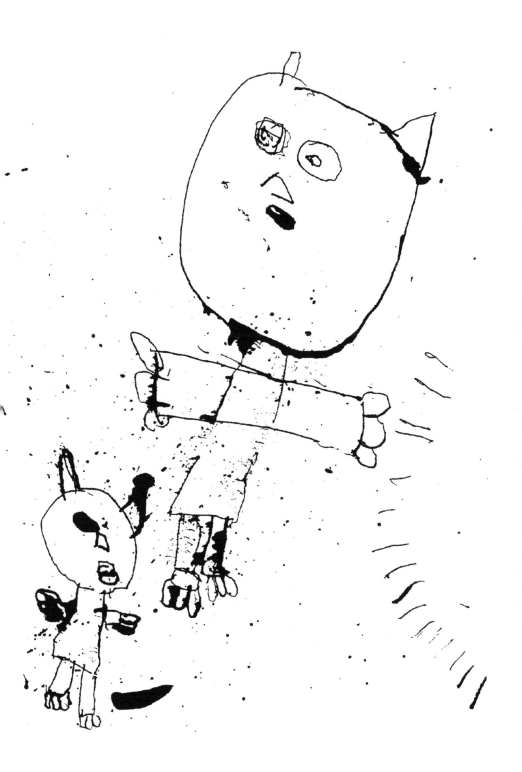

153

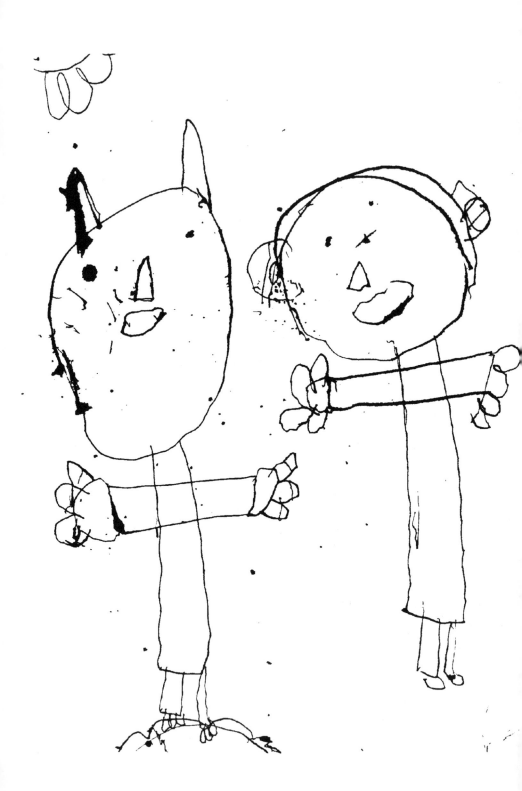

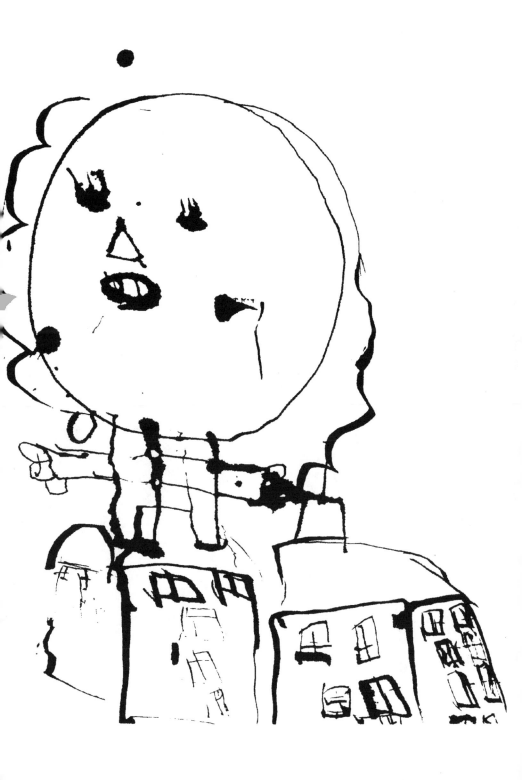

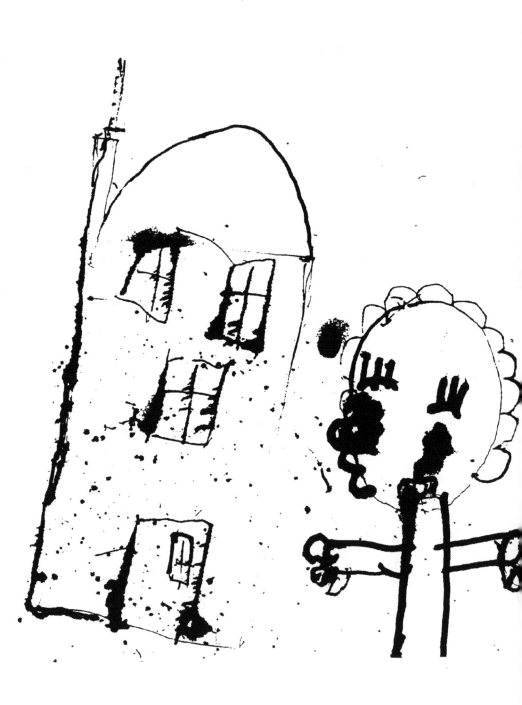

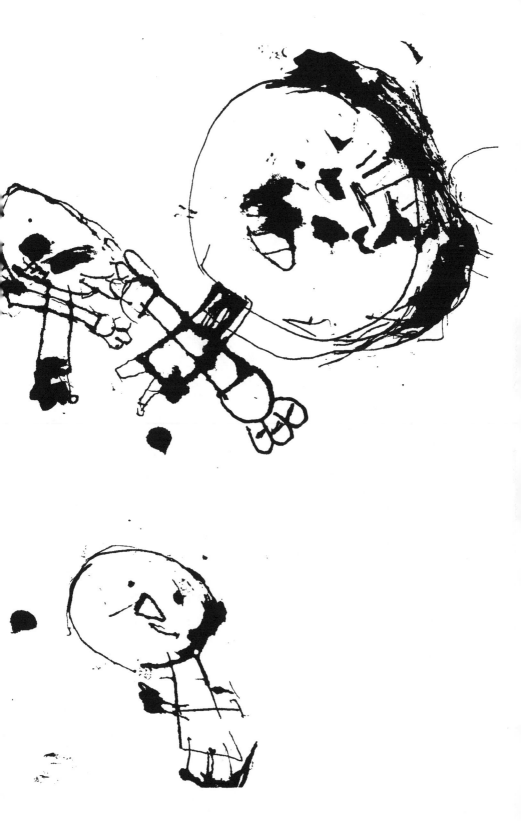

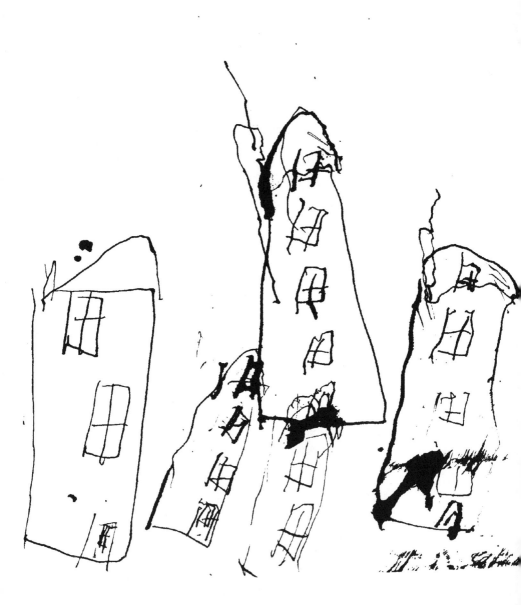

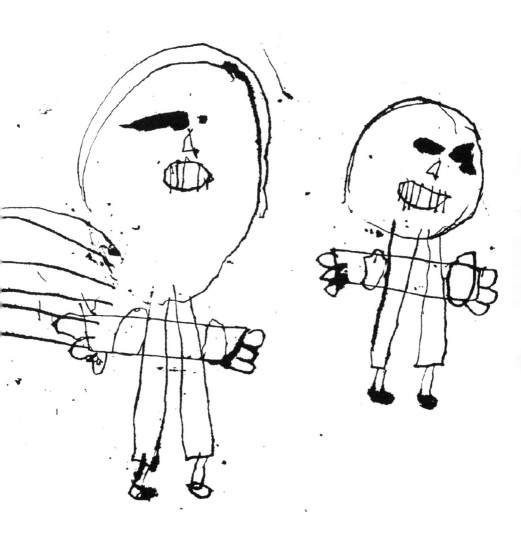

Diane Scaccalosi
Interviewed by Elizabeth Meyer, Harrell Fletcher, and Robert Margolis

Elizabeth: Tell me about the place where you live right now.

Diane: I used to live with my mother. But she's not in this life no more.

E: I'm sorry to hear that.

D: But my brother is.

E: Where does he live?

D: I forgot.

E: Did you grow up around here?

D: Me and my brother were born in San Francisco. I was born in Children's Hospital. I'm the youngest. How old I am, I better not say it.

E: Who do you live with?

D: I live with Terry and Marcie and Diana and the housekeepers. We are the roommates. They are the cookers. My roommate's name is Joyce.

E: What is Joyce like?

D: She is a girl.

Harrell: What do you do when you go home?

D: Oh, I watch television with my roommate. She can't see. She is blind.

E: Do you do any artwork at home? Like drawing?

D: Yes.

H: When did you start drawing?

D: My cousin taught me, and she taught me to say prayers, too. We did a lot of things. We played school.

H: What are your favorite things to draw?

D: Like houses and faces.

H: Who are the faces of?

D: Oh, I just make them up. Or I see a picture in a magazine. I like flowers, too.

Robert: Do you like it here, Diane?

D: I don't really know about that. Sometimes yes, sometimes no.

E: How come?

D: I don't know. It's the way I feel.

R: How many more years do you want to come here, Diane?

D: I don't know.

R: What do you do on Saturday and Sunday, Diane?

D: Well, I watch television and I color.

R: Have you ever been on any trips, Diane?

D: No, I went to the Rec Center. I stayed in the Rec Center. They don't let me go certain places.

R: How are you getting along at home, Diane?

D: Sometimes I don't get along. When I was living with my mother... Now everything is mixed up and I only have my brother and my cousins on my mother's side.

R: How many minutes in this interview?

D: I'm Italian. My father was born in Italy, but I was born in San Francisco. I am the real Diane. I am the only one in this world.

R: What things do you like to do, Diane?

D: I watch television. I do my stuff. I sleep. I eat, and I take my pills.

R: I don't have any more questions to ask, Diane.

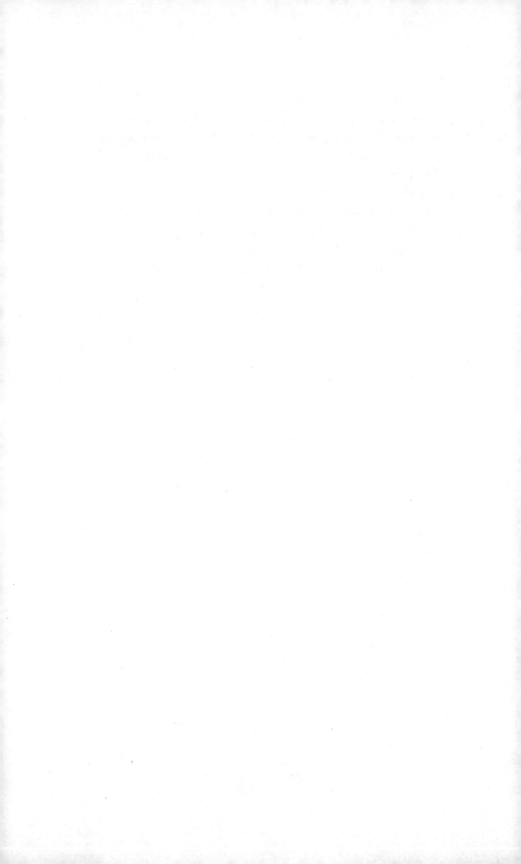

whipper snipper nerd

Gracie

ISSUE #9

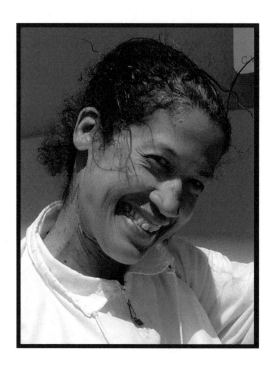

Christina Marie Fong
ISSUE #9, March 2018

Christina Marie Fong was born in 1967 and moved to the Bay Area from Hawaii. She is influenced by fashion, pop culture, and mass media, and her work ranges from drawings of pop culture icons to elaborately detailed paper sculptures of designer handbags. She joined Creativity Explored in 2011. Christina's work has been included in *Bay Area Now 7* at Yerba Buena Center for the Arts, San Francisco (2014); Musée de la Création Franche, Bègles, France (2014); and Bedford Gallery, Walnut Creek, California (2013).

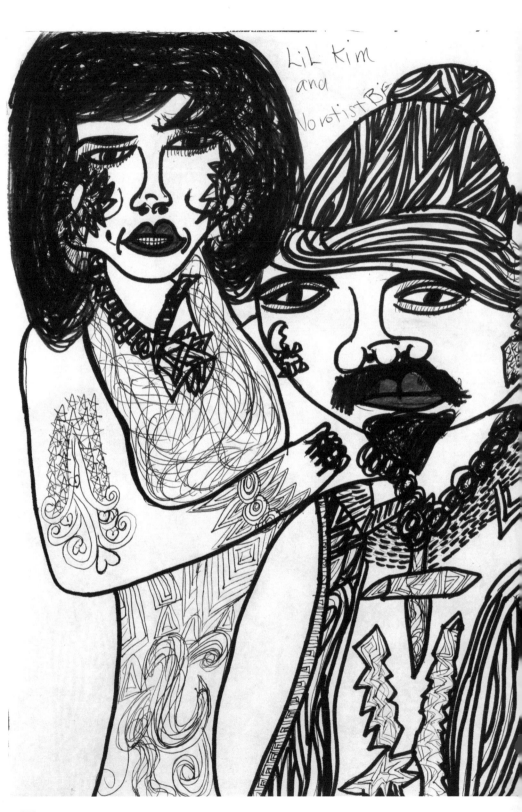

IF you're not
Back by midnight...
you won't be coming home!

PROM
NIGHT

167

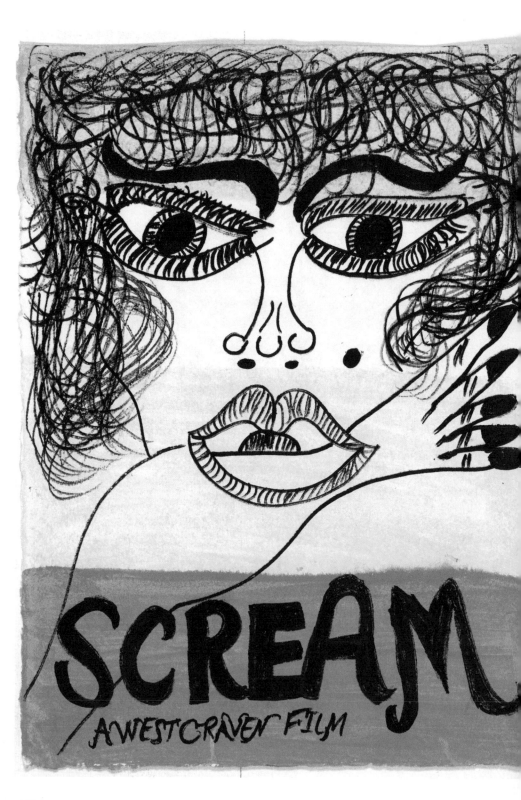

A steven spierberge Productions
A tube hooper film

POLTERGEIST

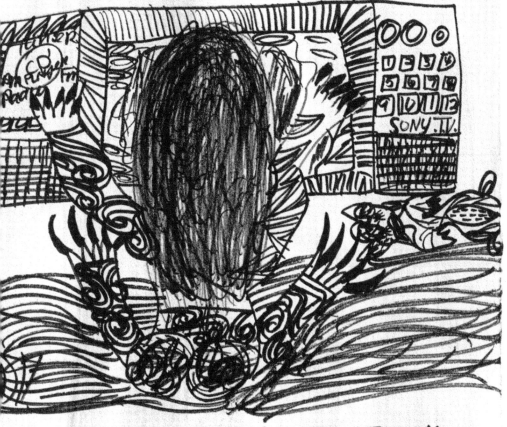

IT KNOWS WHAT SCARES YOU.

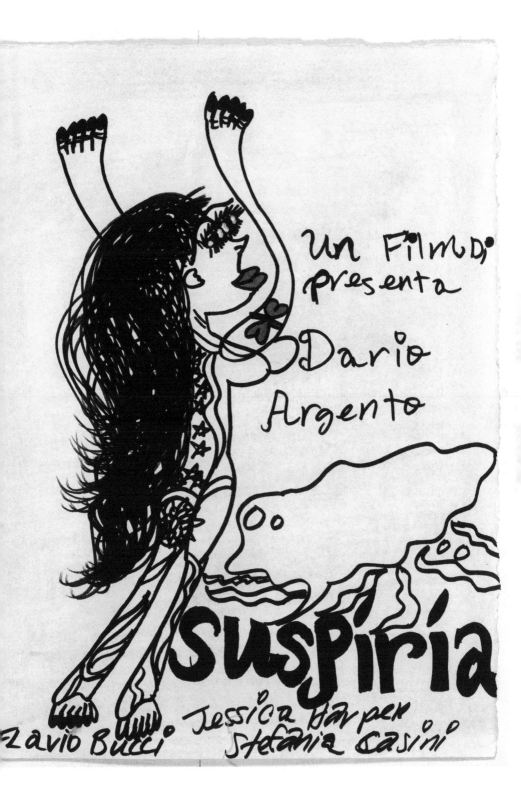

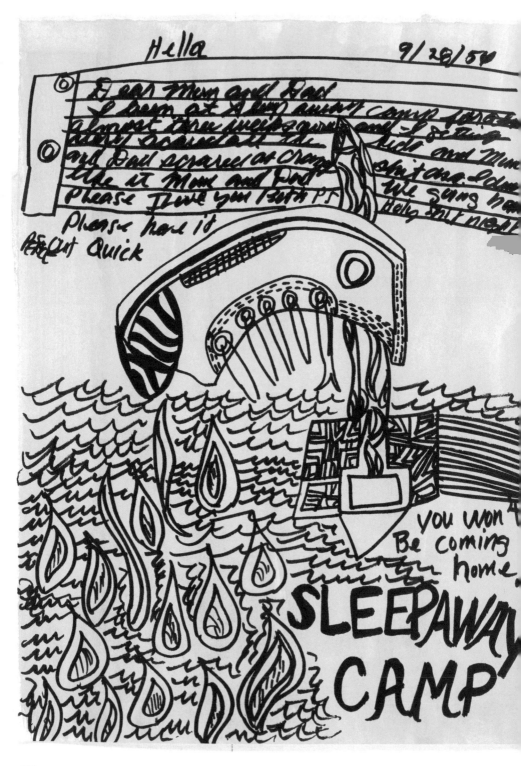

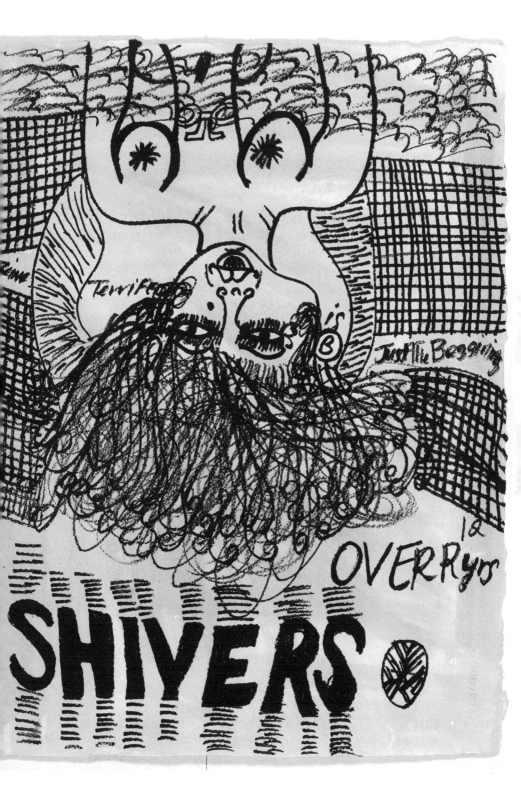

173

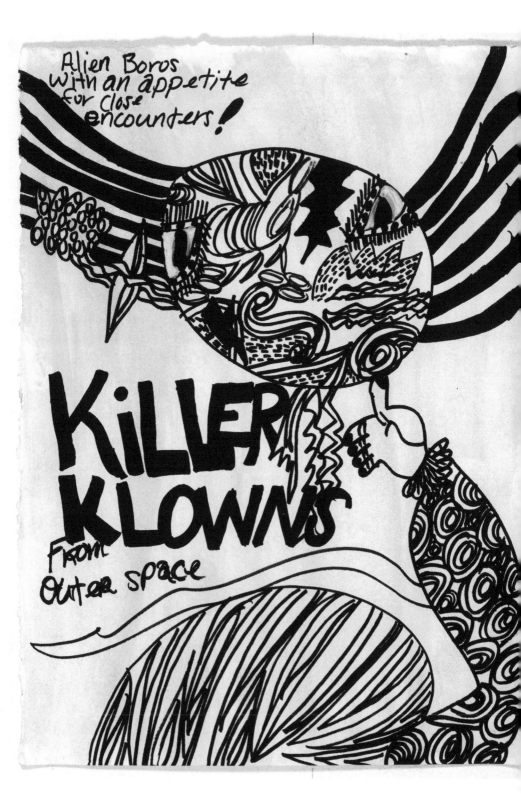

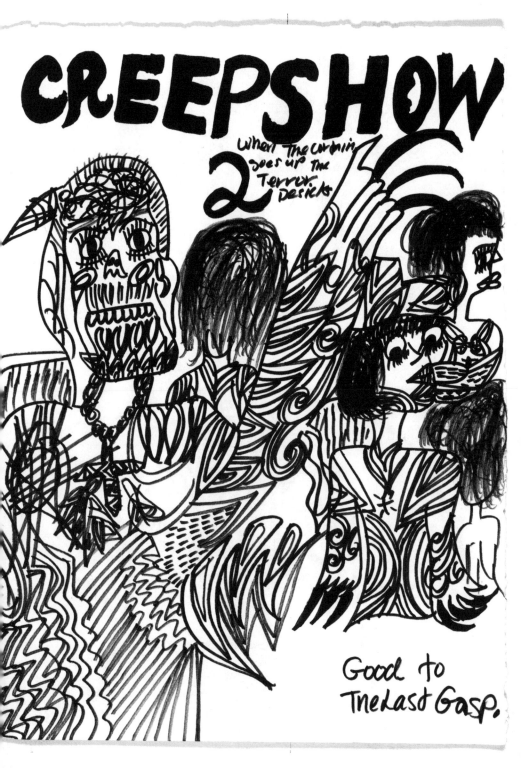

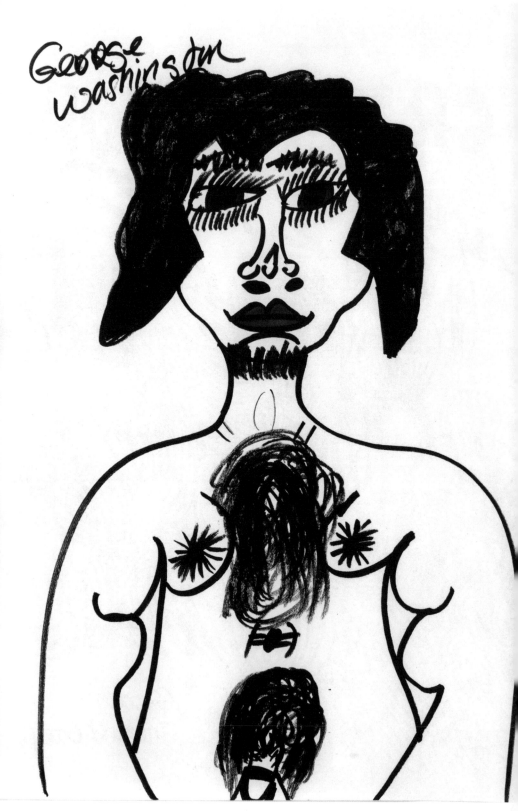

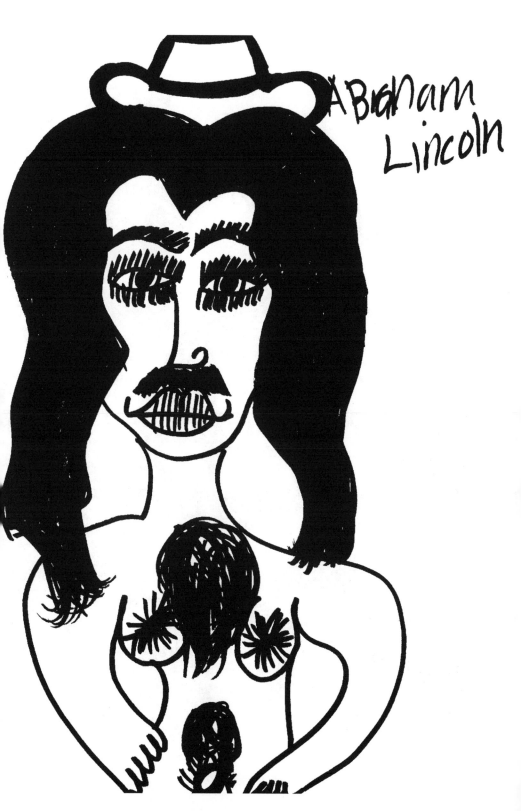

Abraham
Lincoln

177

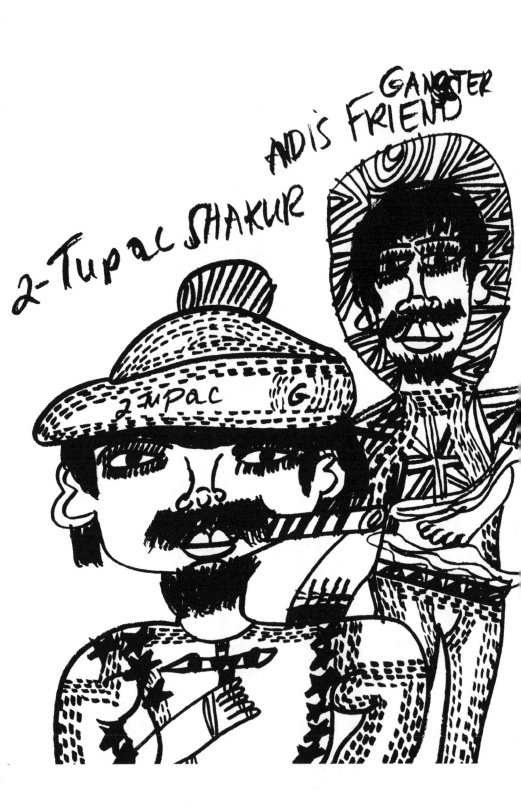

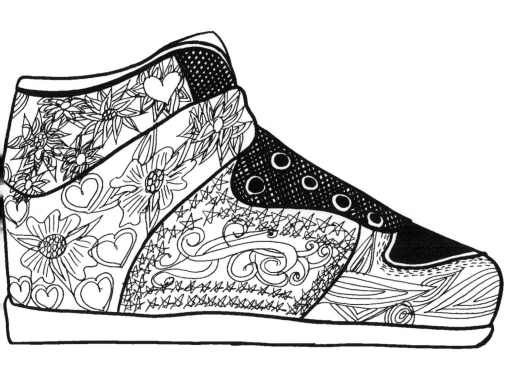

Christina Marie Fong

Interviewed by Harrell Fletcher and Elizabeth Meyer

Harrell: Did you grow up in San Francisco?

Christina: I was born and raised in Hawaii. I came here when I was thirteen. I went to school here. Then I went to college. I went to San Francisco State. I was in a lot of schools here.

Elizabeth: What was it like growing up in Hawaii?

C: I remember the food, the beaches, the volcano—everything. I've got two sisters. They are younger than me. I'm the oldest. I have one brother, too—two twin sisters and one brother.

H: Did they all move to San Francisco with you?

C: They all live in Waikiki. And I have family in the Philippines and everywhere.

H: Have you been to the Philippines?

C: Yeah.

H: What was it like there?

C: It is always hot there, sometimes up to a hundred and twenty degrees. I miss Hawaii a lot, everything there—Hawaiian cupcakes, Hawaiian pancakes. I miss it a lot. But I came here and did some modeling.

E: What do you like about modeling?

C: Oh, fancy clothes, mostly everything.

H: What made you decide to make the movie posters?

C: I do animals also.

H: You like animals?

C: I love animals.

H: What do you like about showing your work to other people?

C: People think I'm very talented, creative, smart, and I know I get things done...

H: That's nice.

C: Have you ever watched a movie called *Texas Chain Saw Massacre*?

H: I've never seen it. I'm very sensitive to violence in movies.

C: That's a good thing. How about *Chucky*?

H: No.

C: *Bride of Chucky*?

H: I can't watch any horror movies.

C: I don't blame you. How about you?

E: I might have tried to watch *Texas Chain Saw Massacre*, but I couldn't handle it.

C: You know what happened when I went to go see a movie with my friend? I left her in the theater and I went home. I caught the Muni and went home.

H: You made movie posters for all of those movies.

C: Uh-huh, they are scary looking.

H: You made one for *Carrie*.

C: Oh, *Carrie*, that movie, ohhh. I don't like her either.

E: Did you see all of the movies that you made posters for?

C: I saw *The Exorcist*.

H: What other posters did you make?

C: *Scream*.

H: All horror films?

C: Yeah, I do a lot of things. I'm just interesting.

E: It seems like you are interested in fashion. I'm curious to know about some of the things that you are really interested in.

C: Modeling, fashion, artwork. I keep myself busy, focused. I never fall asleep on the job, when I'm working. That's why I do one cup, two cups. If that coffee don't get it done, I have a soda.

E: So you start out your day with...

C: Coffee in the morning, first thing. I go for that cup, java. If you don't, you will fall asleep. Then you won't know what you are doing.

whipper snapper nerd

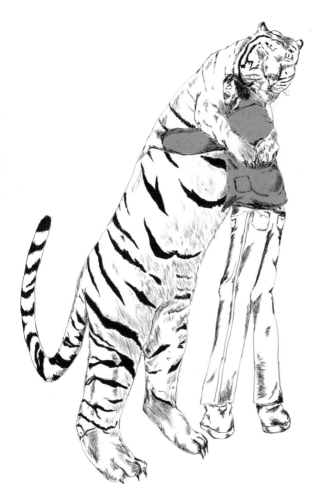

ISSUE #10

Gerald Wiggins
ISSUE #10, March 2018

Gerald Wiggins was born in 1968 and as a child moved from Mobile, Alabama to San Francisco with his family. In 2008, he joined Creativity Explored where he has created a large body of drawings using colored pencil, marker, graphite, watercolor, and digital applications. Gerald also creates ceramic sculptures, including a rotating cast of life-like city dwellers he calls "the crew." His work has been shown at San Francisco International Aiport (2013), Oakland International Airport (2016), and the California Museum in Sacramento, California (2017).

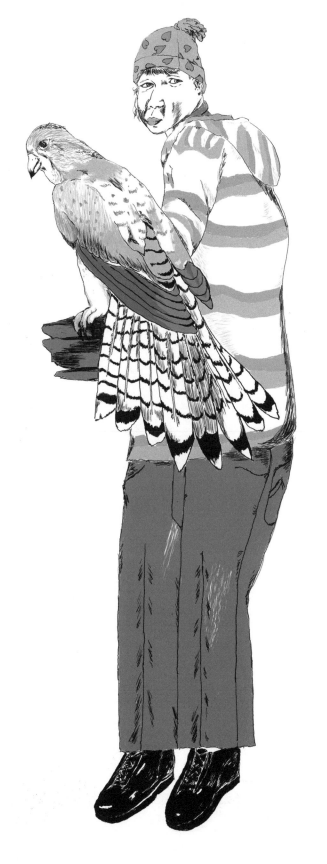

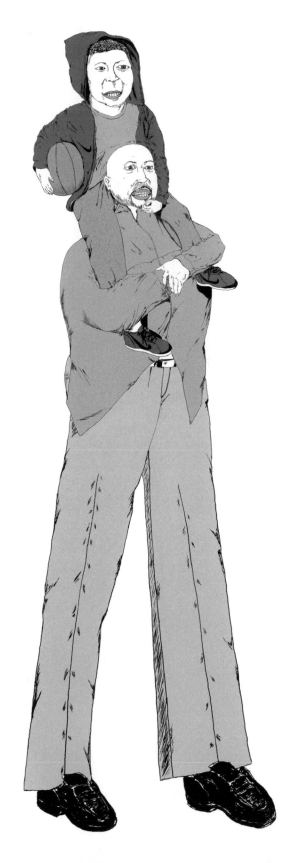

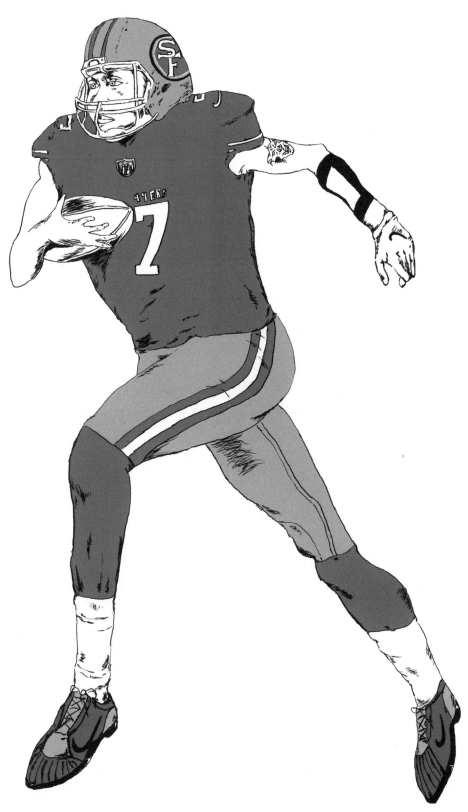

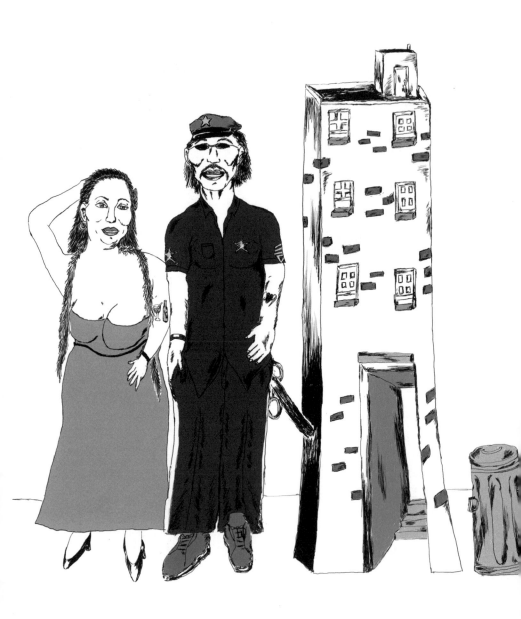

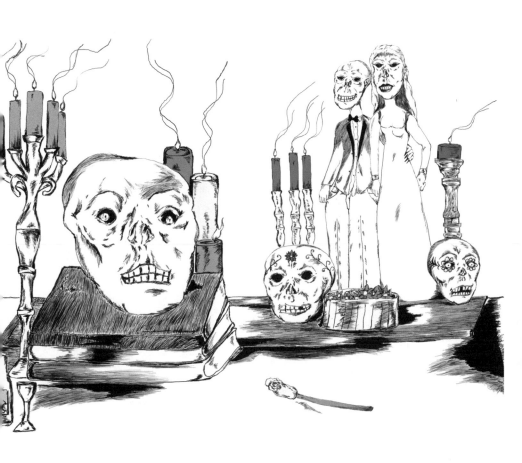

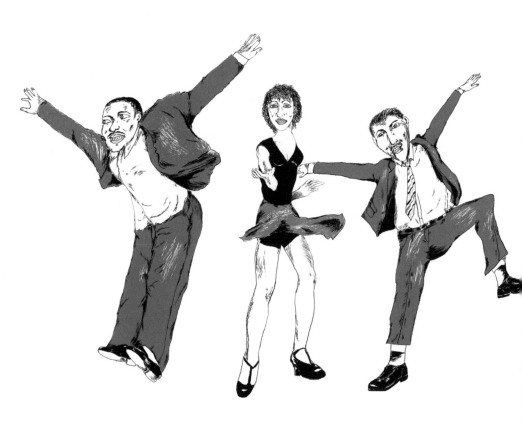

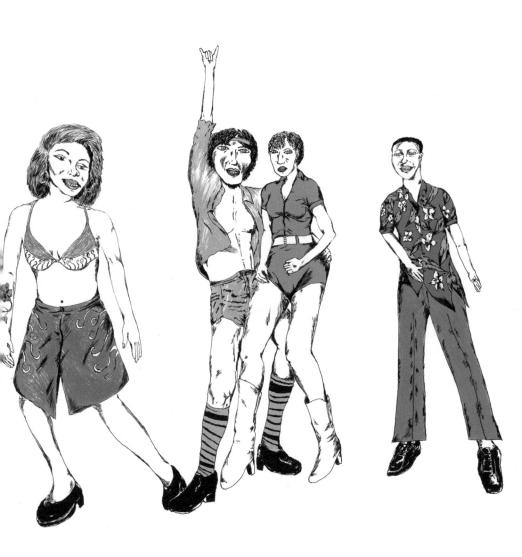

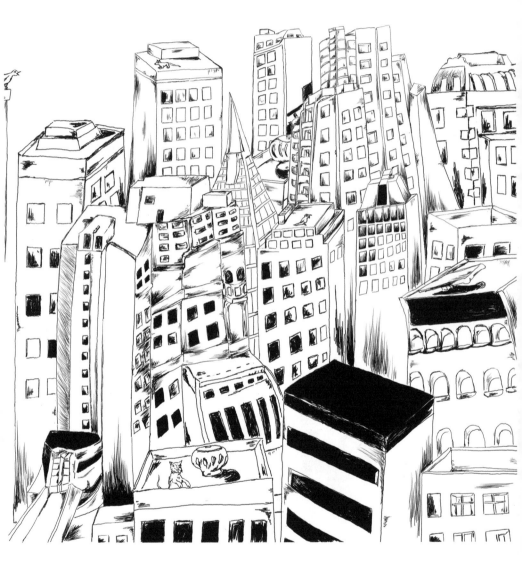

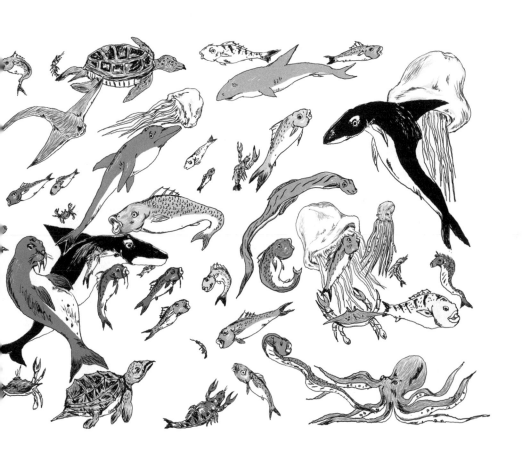

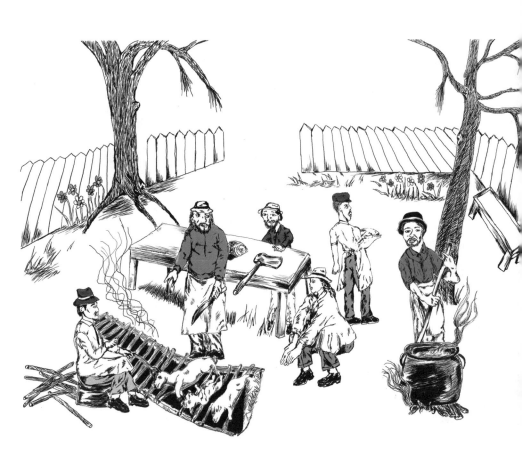

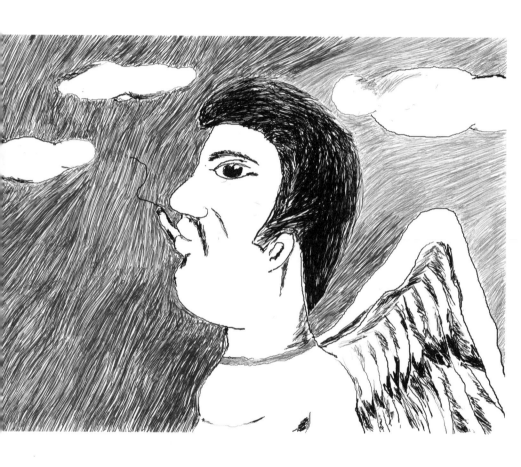

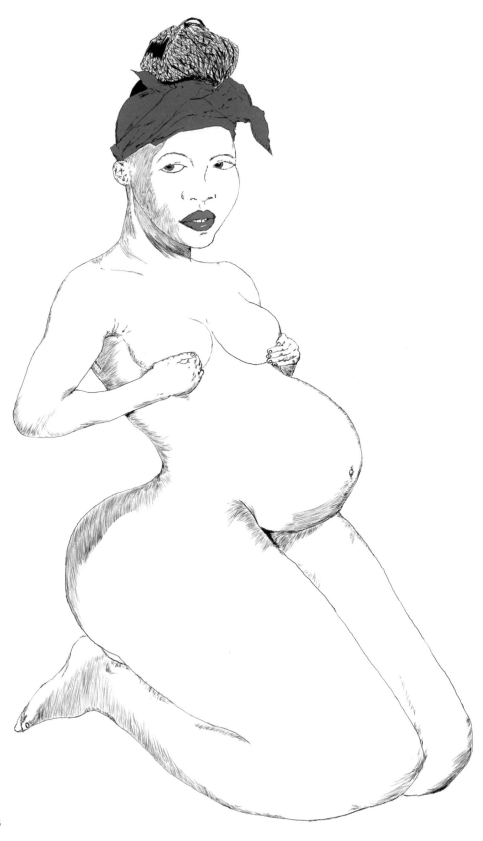

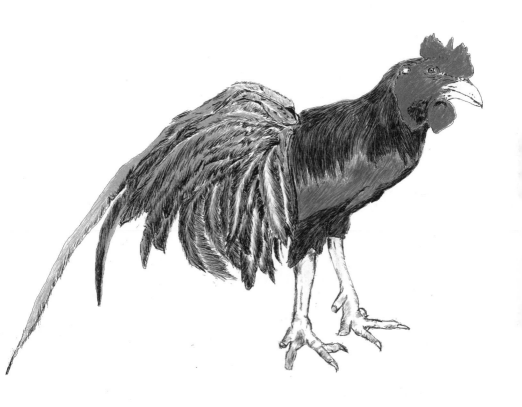

Gerald Wiggins
Interviewed by Harrell Fletcher and Elizabeth Meyer

Harrell: How long have you lived in San Francisco?

Gerald: Since I was eight or nine. I came from Alabama. Mobile. When I was little, me and my mom and my sister used to go out fishing.

H: And then you moved to San Francisco?

G: Yep, before the beard.

Elizabeth: Who do you live with?

G: Just my mom. My sister, she got married and moved out with her two kids to Antioch.

H: How'd you get interested in making art?

G: My doctor said I should look into making art, and they sent me to the Regional Center, and I've been coming here ever since.

H: How do you decide what to draw?

G: I like cute stuff. I find photos on the computer. I just find a picture that I like and I draw the picture.

H: How was that, learning to draw on the computer?

G: It was fun once I got started with it.

H: What are the different types of drawing tools on the computer that you like to use?

G: I like the zoom in and zoom out, the colors. I just like everything about it because I can mix it up with the computer and the drawings.

E: One thing I've noticed in your drawings is that sometimes you combine a human body with an animal face or an animal body with a human face. How did you start doing those?

G: In ceramics I first made a birdman. I thought it would look good as a person because people like animals, and people like persons, so I just mixed 'em together.

H: What's this drawing about?

G: A smoking angel.

E: Why is he smoking?

G: He's thinking. Thinking about what he wanted to do when he's not an angel no more. Someone tried to take his wings. They couldn't take it from him. He's thinking about what he's going to do to them when he gets his wings back. He's smoking to calm his nerves, like a regular person. He's a good guy. But the people who tried to take his wings weren't. They were bad dudes. They thought he would be miserable, but he wasn't. But he wasn't going to let them get away from it.

E: When you start an artwork, do you often have an idea of what the end product is going to look like?

G: I think it just sneaks up on you while you're doing it. It creeps up out of nowhere. And you go with it. You shape it and see where it goes.

E: How is it working in this open studio?

G: I just tune them out. It gets louder at lunchtime. You hear everybody more.

E: Do you bring your lunch?

G: No, I don't eat lunch. I wait until I get home because I like to eat in front of the TV.

E: You don't get hungry?

G: No. I always tell 'em I'm a machine. I get on the computer and I just draw.